the
mandala
guidebook

**how to
draw, paint
and color
expressive
mandala art**

**KATHRYN
COSTA**

NORTH LIGHT BOOKS
CINCINNATI, OHIO
createmixedmedia.com

CONTENTS

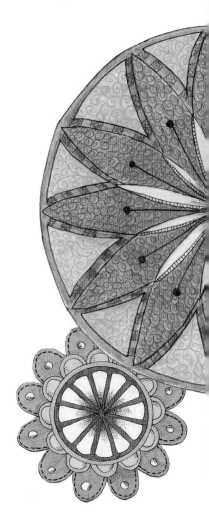

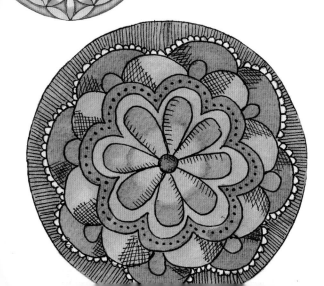

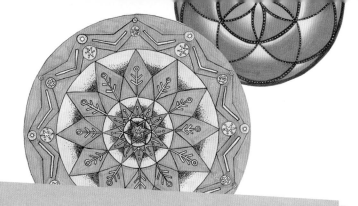

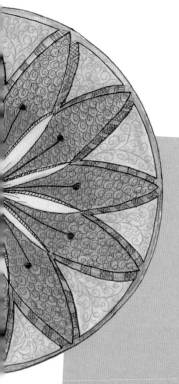

WHAT YOU NEED

Surfaces

bristol board

canvas

cardstock

drawing paper

mat board, white

mixed-media paper

sheet music and other found papers

wallpaper samples

Drawing Tools

blending stump

compass

erasers

fine point pens, black

pencil sharpener

pencils, graphite

protractor

ruler

Coloring Tools

brushes, assorted

charcoal pencils, black and white

colored pencils, water-soluble

craft acrylic paints

fluid acrylic paints

gel pen, white

ink pads and sprays

markers

paint pens

watercolor paints

Mixed Media

brayer

craft knife

foil paper scrap

game spinner with brad

Gelli plate and acrylic base

gesso

glue and glue stick

hole punch

makeup sponge

mat board for framing

old gift card

old magazines

palette or palette paper for mixing

palette paper or freezer paper

paper towels

scissors

sewing-pattern tissue paper

soft gel (matte) medium

spray bottle of water

stencils

wood icing

INTRODUCTION

WELCOME TO THE CIRCLE. IT'S A PLACE WHERE WE:

- Play with colors, shapes and patterns.
- Relax and let go of the worries from the day.
- Listen to our hearts and inner wise selves.
- Discover new ways of healing.
- Connect with other mandala enthusiasts from around the world.

Mandala is a Sanskrit word that means "circle" or "center." We often associate the word mandala with circular designs that have colors, shapes and patterns repeating from the center. Mandalas can be precise, carefully measured, geometric and perfectly symmetrical, or in contrast, free flowing, organic and asymmetrical.

You'll begin to discover mandalas everywhere like rose windows in churches, Native American dream catchers, Celtic spirals, and yin and yang symbols to mention a few. They appear in all cultures and in all time periods. You'll see them in jewelry, fabrics and carpets, as well as in nature.

Mandalas are a form that welcomes everyone. I love watching beginners who don't believe they can draw discover the joy of creating beautiful mandalas. For the experienced artist, the mandala is an invitation to explore the boundaries of design and form and to experiment with familiar and new mediums. Creating mandalas can be a warm-up exercise to activate one's creativity before working on other projects, or it can be a satisfying final destination.

I enjoy the quiet time during my mandala practice, where I unplug from social media, turn off the TV and put on some relaxing music. Before I begin, I often set an intention that may be focused on gratitude, prayers or a problem to be solved. Other times it is a desire to relax and pause from the busyness of my daily life.

When I set out to create this book, I considered what I would have liked to know when I was discovering mandalas. This book offers a wide range of styles, techniques and mediums for creating beautiful mandalas. The projects in chapter 10 take the practice of making pretty pictures to a deeper, more meaningful level where we explore the meanings of our mandalas and create with intention.

This book will serve as a companion for those who take up my challenge to create 100 mandalas in 100 days. There are so many possibilities found within the simple circle. I'm eager to see your mandalas and hope you'll join me and thousands of other mandala enthusiasts from around the world at **100mandalas.com**.

Kathryn Costa

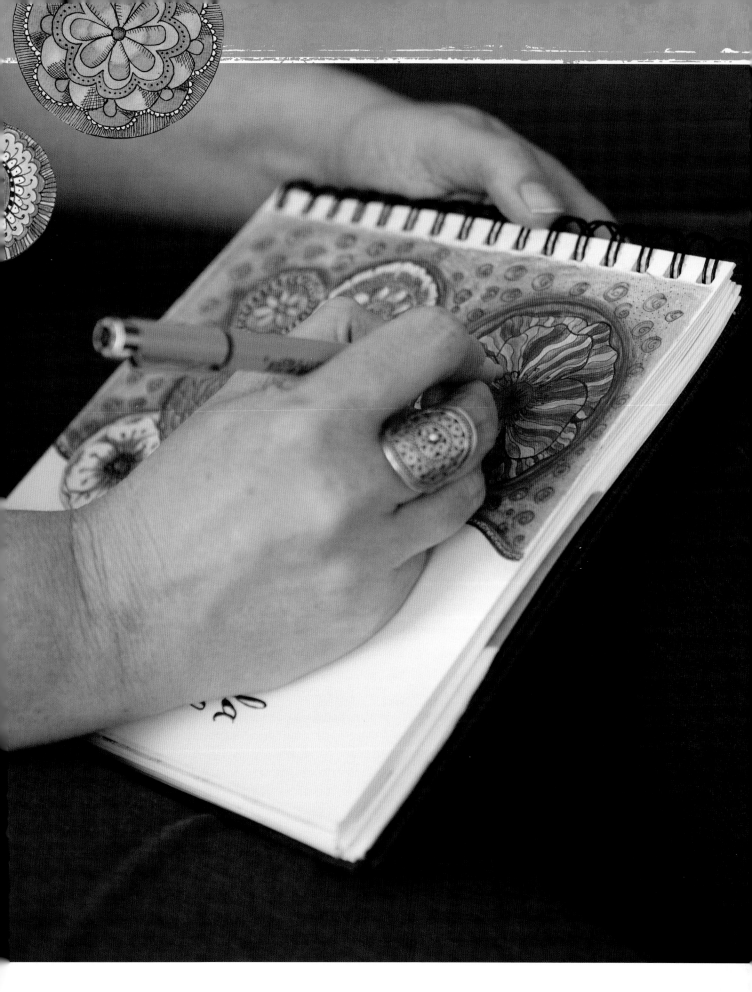

DRAWING TOOLS

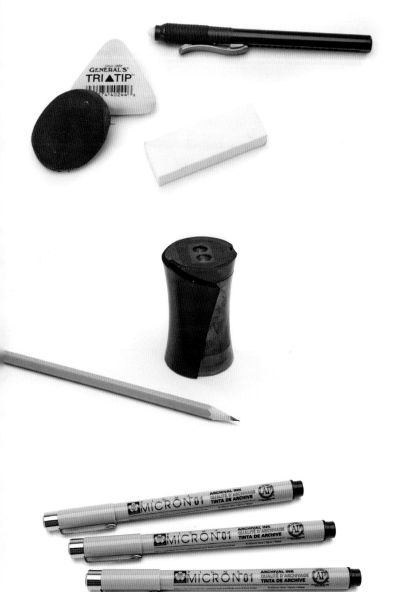

It can be overwhelming to walk into an art supply store and see all of the products and options. It can also be very exciting. I always recommend that you start with what you have on hand and then add new tools and supplies as you grow into your mandala practice. If you've been crafting for years or are a seasoned artist, then now is a great time to dust off some of those long-forgotten art supplies. Have fun discovering or rediscovering the many artistic possibilities within the circle.

PENCILS AND SHARPENER

Pencils vary from hard to soft. For drawing, you may like the fine point of a mechanical pencil. You'll need a sharpener for drawing pencils and colored pencils. My handheld Prisma-color sharpener has two openings to get both broad and fine points. It is also a convenient size for traveling.

ERASERS

Erasers come in a variety of shapes and materials. Two types of erasers I use often are rubber and vinyl erasers. Pencil-shaped erasers are helpful for erasing details whereas the other sizes and shapes work well for larger areas.

When drawing mandalas, you may find yourself erasing a lot of guidelines. Be sure to erase gently so you do not tear the paper. Clean the eraser often as you work by rubbing it on a fresh piece of scrap paper so you don't rub graphite onto your drawing.

FINE POINT PENS

Ideal for drawing intricate patterns and details, fine point pens come in a range of sizes and colors. My favorite fine-liner pens are made by Micron. I recommended starting with black in a few sizes: 01, 05 and 08.

compass and protractor

One of the essential drawing tools for creating circles is a compass. The compass has two arms: One arm has a "needle" on the end of it, and the other arm has either a place to insert a piece of lead or an opening for a pen or pencil. Connecting the two arms is a hinge that you turn to adjust the width. When looking for a compass, consider the size circles you will want to make. For the exercises in this book and for drawing in journals, look for a compass that creates circles from ⅛" (3mm) to 12" (30cm) in diameter. Avoid cheap compasses as over time they loosen and will not hold their position. It is really frustrating to work with a compass that "flies out" while you are trying to draw a circle.

Protractors are used for measuring angles. They come in a variety of sizes and are made of clear plastic. Rulers are also essential for creating perfectly symmetrical mandalas. See chapter 2 for instructions on how to use these tools.

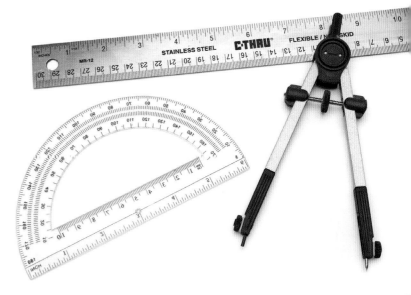

how to measure a circle

To use a compass to draw a circle, place the needle at the center of where you want your circle. Hold the top of the compass with the needle fixed on the center point and rotate the arm with the drawing end using a circular motion. Use a ruler to measure the distance between the two arms. This distance is known as the radius and is half the length of the circle. In the photograph on the right, the two arms are 3" (7.5cm) apart to draw a 6" (15cm) circle.

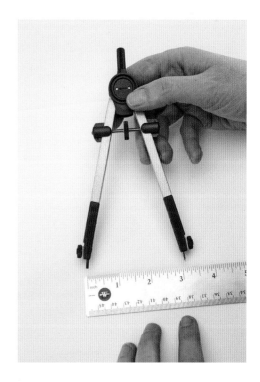

COLORING TOOLS

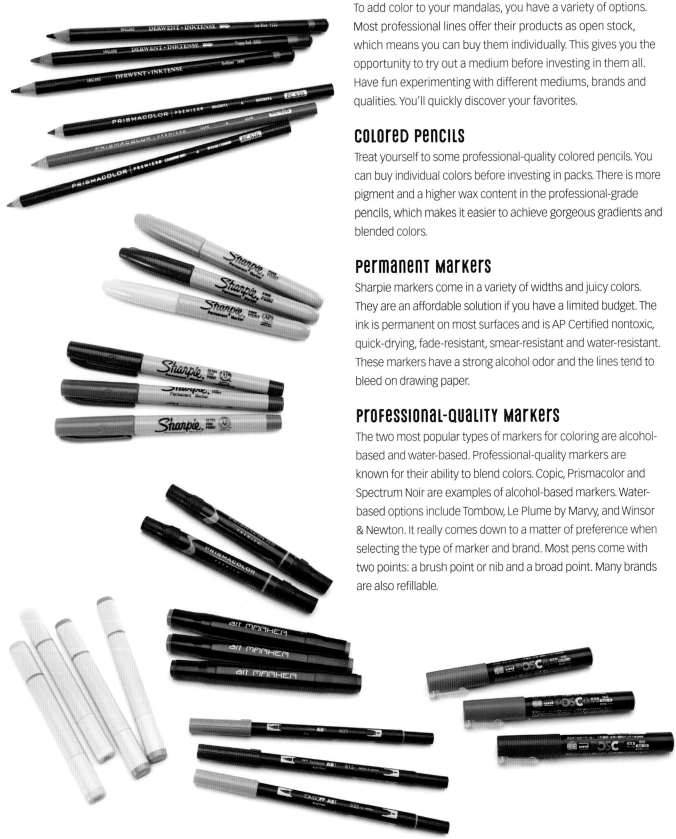

To add color to your mandalas, you have a variety of options. Most professional lines offer their products as open stock, which means you can buy them individually. This gives you the opportunity to try out a medium before investing in them all. Have fun experimenting with different mediums, brands and qualities. You'll quickly discover your favorites.

COLORED PENCILS

Treat yourself to some professional-quality colored pencils. You can buy individual colors before investing in packs. There is more pigment and a higher wax content in the professional-grade pencils, which makes it easier to achieve gorgeous gradients and blended colors.

PERMANENT MARKERS

Sharpie markers come in a variety of widths and juicy colors. They are an affordable solution if you have a limited budget. The ink is permanent on most surfaces and is AP Certified nontoxic, quick-drying, fade-resistant, smear-resistant and water-resistant. These markers have a strong alcohol odor and the lines tend to bleed on drawing paper.

PROFESSIONAL-QUALITY MARKERS

The two most popular types of markers for coloring are alcohol-based and water-based. Professional-quality markers are known for their ability to blend colors. Copic, Prismacolor and Spectrum Noir are examples of alcohol-based markers. Water-based options include Tombow, Le Plume by Marvy, and Winsor & Newton. It really comes down to a matter of preference when selecting the type of marker and brand. Most pens come with two points: a brush point or nib and a broad point. Many brands are also refillable.

PAINT PENS

Uni Posca paint markers use vivid, opaque ink that can write on virtually any surface including paper, photos, glass, wood, plastic and metal. The paint ink can be scraped off from nonporous surfaces like glass but adheres permanently to porous surfaces like paper. It shows up well on both light and dark surfaces, and once it is dry you can write over it with another Posca marker without smearing or anything showing through.

WATERCOLOR PAINT SETS

You can also color your mandalas with watercolor. I love my darling Japanese watercolor set. It comes in a gift box wrapped with Japanese paper. The set includes a palette of six watercolors (gold, red, yellow, brown, dark blue and green) that I've mixed to create the most gorgeous hues, a superfine black hard brush pen for detailing and a refillable waterbrush for painting. I love to travel with this set.

ACRYLIC PAINTS AND BRUSHES

For stencilling, I use inexpensive acrylic paints and brushes sold at craft stores. The lighter-body acrylic paints in light colors work well for mixed-media mandala projects.

INK SPRAYS

One of my quick and favorite ways to create an interesting background is to spray the page with spray inks. These can be applied to a blank page as in the labyrinth project found on page 120 or combined with other painting techniques as demonstrated in chapter 8.

INK PADS

The 2" × 2" (5cm × 5cm) Distress Ink Pads from Ranger come in more than fifty colors. They can be rubbed and stamped onto paper to create a weathered, aged or vintage look. Learn how to use these inks to create an interesting collage background on page 84.

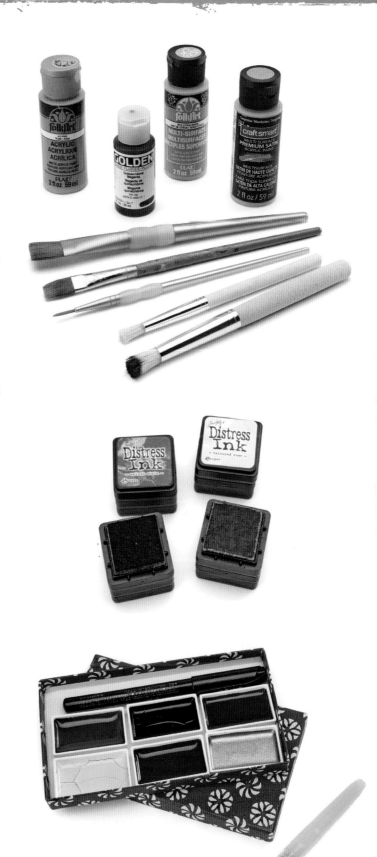

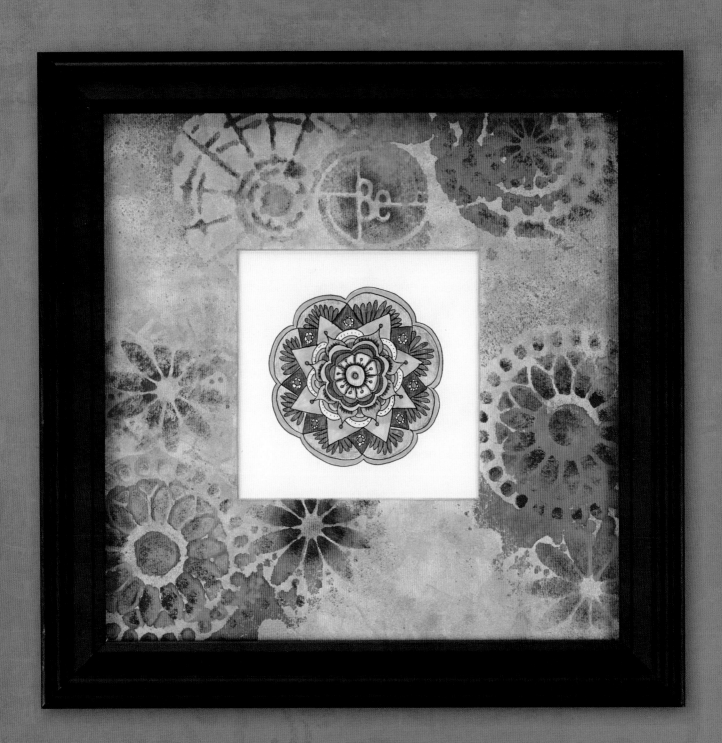

1 | THE FREEHAND METHOD

IF YOU CAN WRITE YOUR NAME, you can draw a mandala. In writing we have a variety of straight and curved lines. Just look at the curved, horizontal, vertical and diagonal lines in these letters: A, B, C, D, E, S. In mandala making, we use these same basic structures and organize them around a center point, working our way outward stroke by stroke. What I like the most about this technique is that you only need two things: a surface and something to make your marks. If you are feeling intimidated, pull out an ordinary lined notebook and a ballpoint pen. Follow the steps in this chapter to get the hang of drawing mandalas freehand. Pick up some inexpensive gel pens in funky colors and play like you did when you were a kid. Copying allows you to get a feel for a technique and style; this is a great way to get started. With each mandala that you draw, your own unique style will develop. I encourage you to play, trust your intuition and experiment. You will find, just as I have, how rewarding it is to design your own mandalas.

" … there are no wrong turns, only unexpected paths." —Mark Nepo

◄ **Mandala Art With Custom Frame** | Kathryn Costa
Markers and colored pencils on bristol board

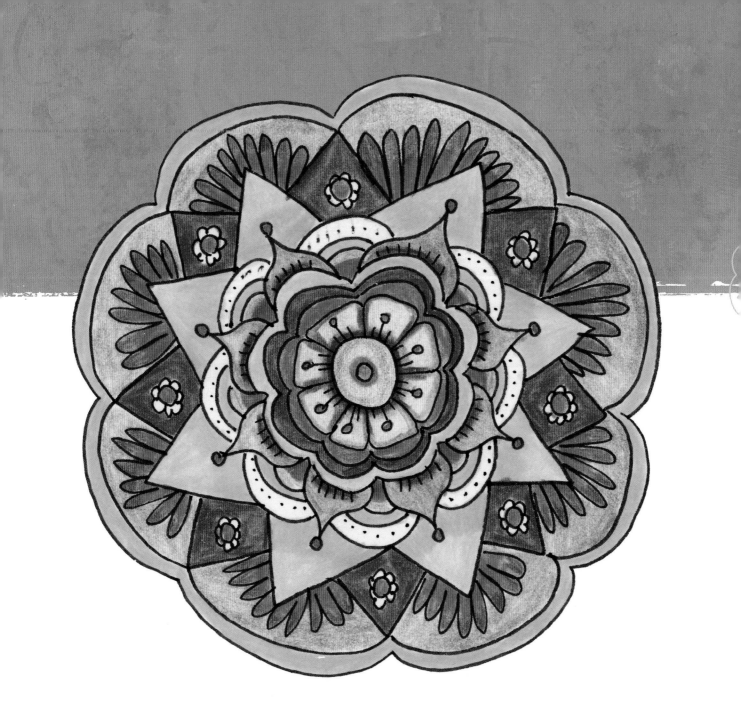

How Imperfections Can Disappear

Start at the center and notice the shapes, then move to the next row of petals. Start at the top of that row and again look at each individual petal. Are they exactly the same size and shape? They are close, but they are not perfect. What I love about this whimsical drawing style is that it is very forgiving. Add color and the imperfections seem to disappear. The trick is to go in and add lots of little details

Spring Flower Mandala | Kathryn Costa
Colored pencils on bristol board

GROW A FREEHAND MANDALA

I'M A RECOVERING PERFECTIONIST. When I started drawing mandalas I struggled with making all my lines even and perfect. I tried using a ruler and stencils to create what I thought were perfect mandalas, but there was something missing and that was my unique style. After drawing many mandalas, I eased up on myself and began to really enjoy the process. The more I enjoyed drawing mandalas, the more my lines took shape in a way that was a reflection of me. Now when I look at the imperfect, wonky lines, I see a charm and spirit that was absent in my "perfect" mandalas. In this demo I show you how to grow a mandala by starting at the center and working outward, line by line. For your first mandala you may want to copy each step in this demo. Once you get the hang of it, have fun varying the shapes.

MATERIALS LIST

- paper
- pencil or fine point pen
- colored pencils

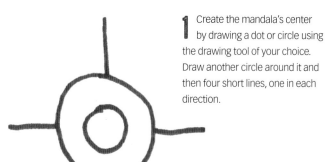

1 Create the mandala's center by drawing a dot or circle using the drawing tool of your choice. Draw another circle around it and then four short lines, one in each direction.

2 Add four lines to the outer circle, here illustrated in red.

3 Connect the lines in a freehand flower shape. Refer to the design sampler sidebar on page 14 for some ideas on fun ways to connect your lines.

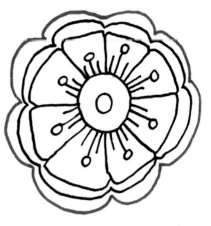

4 Add designs to each shape. As you build your mandala ask yourself, "What's next?" and "How can I connect these lines and shapes?"

5 Outline the petals from the previous step. I chose to curve the lines, but you could follow the same flat petal shape as well.

6 Outlining the shapes is an easy way to add another layer of fullness and interest to the design.

IDEAS FOR CONNECTING YOUR MANDALA SHAPES

Have fun changing the shapes in this tutorial. In the first two rows, start with the same base and connect the top using different shapes. The next two rows are examples of the types of details you can use to fill the shapes. The last two rows are some additional shapes to consider when you draw your next mandala.

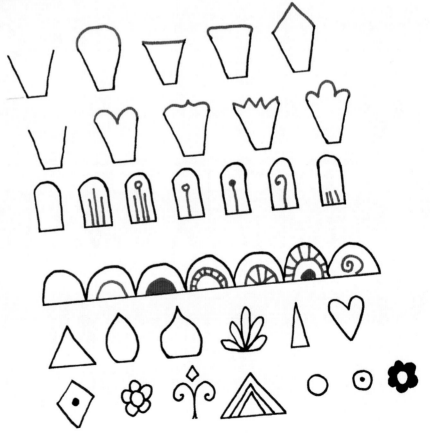

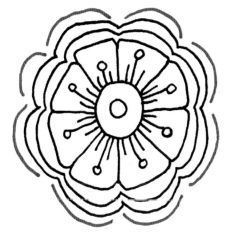

7 This time I outlined the shapes but didn't connect them as I did in steps 5 and 6.

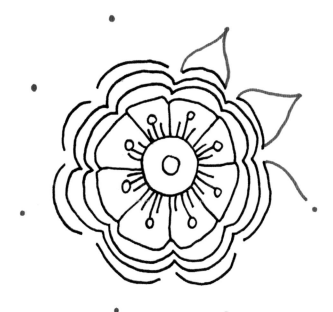

8 Draw dots centered above the lines drawn in step 7. Connect the bottom of each curved line to each dot to create a petal.

9 Connect the curved lines with a V-shape. Add a little circle to the top of each petal.

10 Draw three arches connecting the petals.

11 Draw a straight line from the center of the arch to a midpoint above the neighboring circle to create a triangle. Draw a second straight line down to the center of the next arch. Repeat around the entire mandala.

12 Draw a triangle in between each of the triangles drawn in step 11.

13 Draw an arch that connects the tops of every other triangle.

DON'T FORGET TO BREATHE!

Relax into each mark that you make on the page. Feeling tense? Try playing soft, gentle music. My favorites are classical guitar, Native American flute and *Zen Moments* meditation music.

14 Outline the arches drawn in step 13.

15 Fill in large areas with doodled patterns. This helps to hide uneven lines and makes the mandala more interesting.

16 Add a few final details and embellishments like little dots following the lines of the arches and sweet little flower doodles. When you are satisfied with your mandala design, color it in! I used pink, orange and green colored pencils. See page 12 for the finished colored version and page 10 for a framed variation of this freehand mandala.

ROTATE AS YOU WORK

You don't have to be a contortionist to draw a mandala. Rotate your paper as you work. This will help you draw repeating shapes more consistently.

create a mixed-media mat

SOMETIMES A PLAIN WHITE MAT WILL NOT DO! Here is a quick way to create a custom mat to match your mandala.

MATERIALS LIST

mat board for framing, white

makeup sponge

craft acrylic paint

fluid acrylic paint

ink sprays

stencil

stiff bristle brush

paper towel

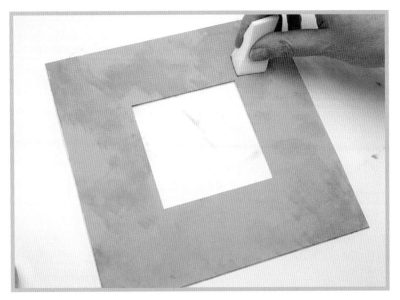

1 Use a makeup sponge to apply a basecoat of pink acrylic craft paint to cover the mat board. Let it dry then apply orange acrylic paint with a makeup sponge.

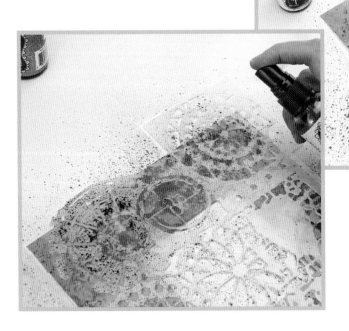

2 Once dry, position a stencil over the mat and spray it with two colors of ink spray. Here I alternated between Ranger's Dylusions Tangerine Dream and Lemon Zest. If too much ink pools up, gently blot with a paper towel. Allow the ink to dry completely. Move the stencil around to various parts of the mat until you have filled the mat.

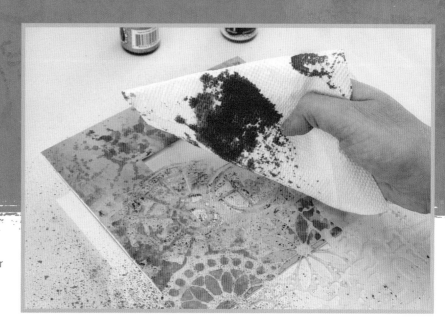

3 Tap a dry paper towel on the mat to remove any excess ink or paint during the painting process.

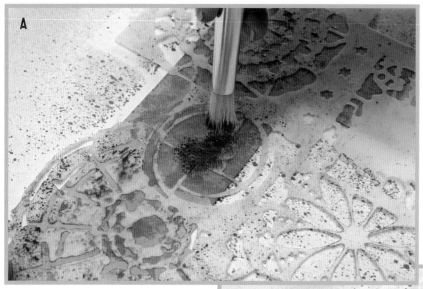

4 Tap a stiff dry brush into magenta craft paint. Try shifting the stencil over to one side to offset the image and add a drop shadow effect. Tap the paint from the brush over the stencil. Turn to page 10 to see my freehand mandala from this chapter framed with the completed mixed-media mat.

mandala your world

EXPERIMENT WITH DIFFERENT BACKGROUNDS including black paper, brown paper bags and sheet music. Use white, silver and gold gel pens on dark paper.

Try This!

1. White gel pen on black paper
2. Silver gel pen on black paper
3. Draw outside the circle
4. Black and white pens on a paper bag then cut out
5. Draw on sheet music

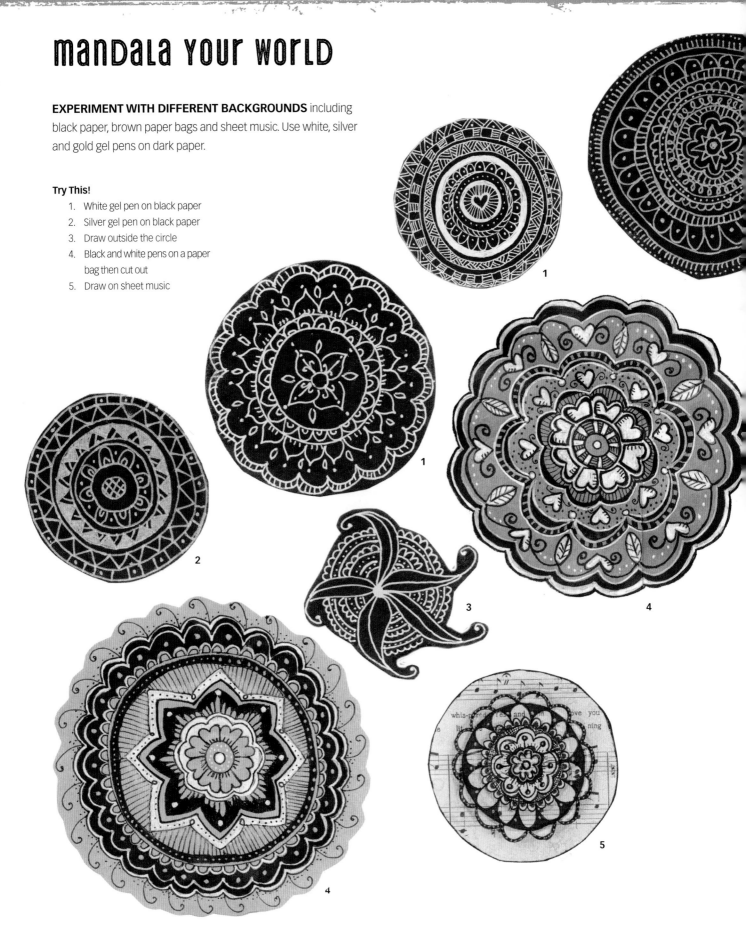

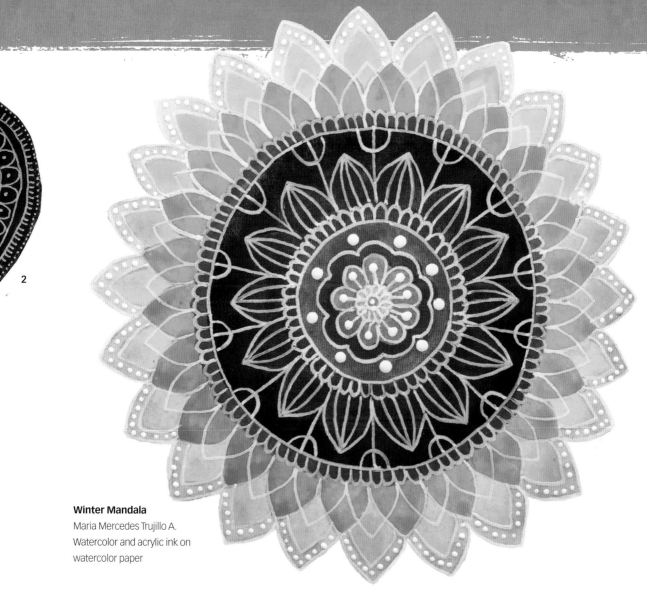

Winter Mandala
Maria Mercedes Trujillo A.
Watercolor and acrylic ink on
watercolor paper

2

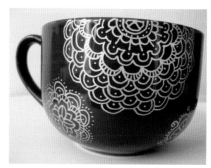

Mandala Mug
When you get the hang of creating mandalas
freehand, the possibilities of where you can draw
a mandala are endless. Sharpie and Posca paint
pens are ideal for adding mandalas to various
surfaces like this mug.

From My Journal to Stone | Maria Mercedes Trujillo A.
Watercolor and acrylic ink on watercolor paper, and acrylic ink on a beach stone

ORGANIC SHAPES

EXAMPLES OF ORGANIC SHAPES FOUND IN NATURE. All shapes fall into two categories: organic and geometric. Organic shapes have a natural, flowing and curving appearance. These forms are typically irregular or asymmetrical. Organic shapes are associated with the natural world, like plants, animals, clouds and seashells, and are considered a feminine form. A mandala composed of primarily organic shapes may appear soft, calming and peaceful.

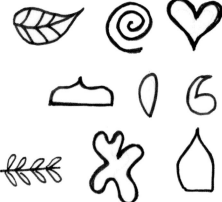

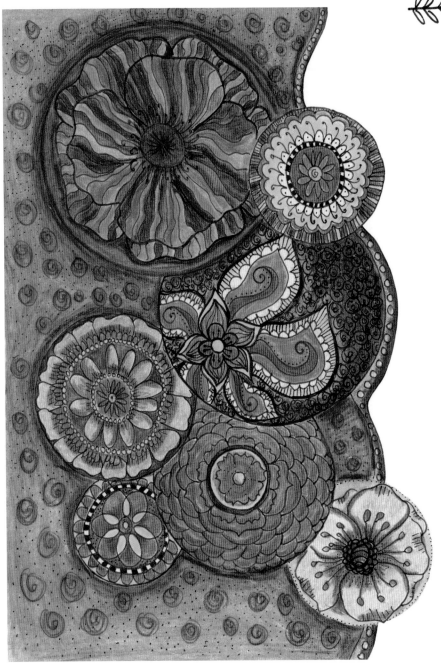

geometric shapes

GEOMETRIC SHAPES ARE MAN-MADE. Circles, rectangles, squares, triangles and hexagons are all examples of geometric shapes typically created by humans using tools. The only perfectly geometric shapes found in nature are crystals. Geometric shapes are easily placed in symmetrical layouts and are considered masculine. The straight lines in geometric shapes can create a sense of rigidity. Mandalas composed primarily of geometric shapes can also have a sense of order and balance. Try mixing organic and geometric shapes within the same mandala.

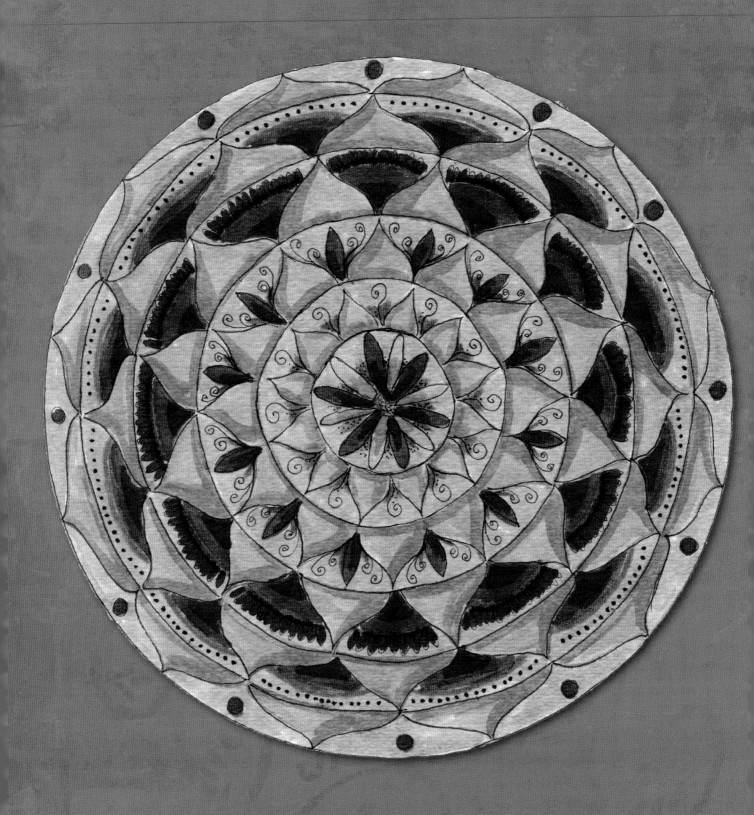

2 | THE GRID METHOD

WHEN I PULL OUT A COMPASS AND PROTRACTOR in my mandala workshops, invariably there are students who recall the struggles they had in math classes when they were in school. One woman bravely shared how she felt blocked by her fears stemming from geometry class. I can so relate. Of all the subjects, math was my worst. Perhaps this is why my students enjoy my lessons involving math; I've overcome my fear and discovered that I'm good at breaking down the steps. It is fun to see the lightbulb moments and hear the "ahhhs" from my students as they get how to break the circle down into segments to create the grid. Once you get the pattern, you too will take off drawing beautifully symmetrical mandalas.

It is important not to skip this chapter, though it may be tempting to jump ahead to some of the other more creative lessons. Here we set the stage for adding fun shapes, patterns and colors to your mandalas. You'll find that I refer to this grid method throughout the book when we draw mandalas on painted papers and collaged backgrounds.

Are you ready to see just how easy it is to draw perfectly symmetrical mandalas? Let's get started.

"A person who never made a mistake never tried anything new." —Albert Einstein

◄ **Lotus Mandala** | Kathryn Costa
Blending markers and black pen on watercolor paper

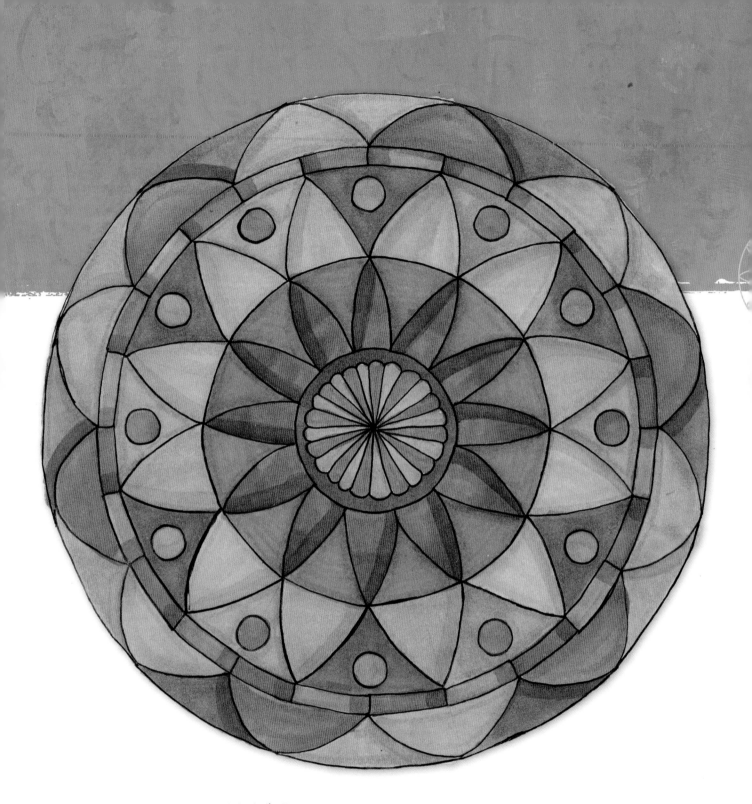

Get Into the Zen

Once you get the hang of drawing repeating shapes within a grid, you can relax and go with the flow. I find that I can get in the flow more easily by setting down the ruler and drawing freehand within the grid. Pick a shape and then follow your breath as you repeat it over and over, working your way from row to row.

Stained Glass Mandala | Kathryn Costa
Blending markers on bristol board

DRAW A MANDALA USING THE GRID METHOD

YOU MAY HAVE FLIPPED THROUGH THIS BOOK many times and admired all of the mandalas and wondered, *How can these mandalas be so perfectly symmetrical?* Drawing a grid is the easiest way to line everything up. In this demonstration I'll show you how, step by step.

MATERIALS LIST

- paper of your choice
- pencil and eraser
- compass
- protractor
- ruler
- black fine point pen
- stencils
- coloring tools

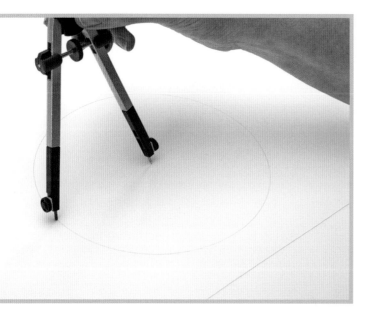

1 Draw a Circle

Select your surface based on the medium you want to use—plain copy paper, cardboard, watercolor paper, canvas or even music sheets. I like bristol board as it works with a variety of mediums.

Place a ruler on your paper and mark a small dot in the middle of the length you wish your mandala to be, then using your compass, draw a circle. In this exercise my mandala is about 7½" (19cm). I suggest working larger for your first mandala.

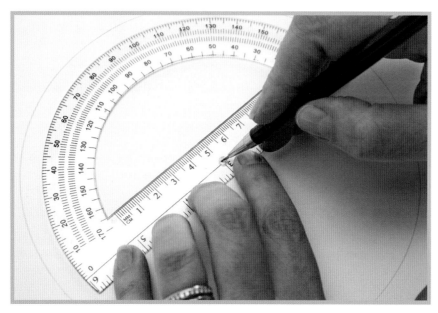

2 Find Your Center

At the center of your mandala, line up the protractor over the center dot placed in step 1.

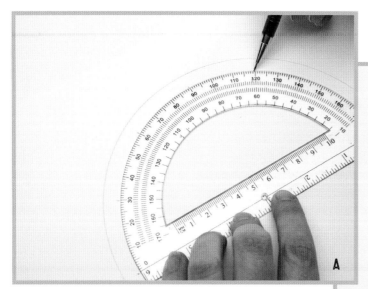

A

B

3 Divide the Circle Into Equal Sections

Divide the mandala into twelve equal sections. Divide 360° by the number of sections to determine how big to draw each section. In this example, 360°/12=30°. Using your protractor and pencil, mark your circle in 30° increments: 0°, 30°, 60°, 90°, 120°, etc. Turn your paper around to mark the same degrees on the other side.

4 Draw the Guidelines

Use the marks you made in step 3 to draw twelve guidelines. Keep them very light because you'll want to erase them in a later step.

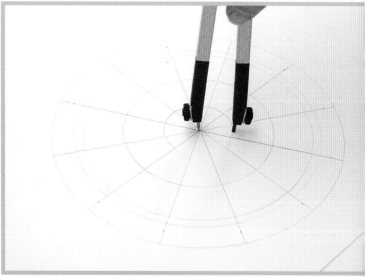

5 Draw Several Circles

Using a compass, draw several more circles. Vary the size of each circle to create an interesting pattern.

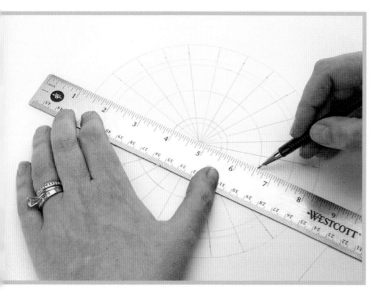

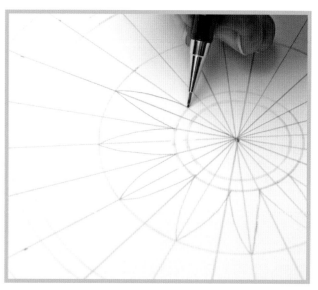

6 Add Midpoint Guidelines

I add midpoints to grids that have twelve or fewer sections. Use a ruler and pencil to add midpoint guidelines between the twelve lines from step 4 to create twenty-four equal sections.

7 Begin Your Design

Using a pencil, connect the bottom of one grid point to the top of the next guideline and then back down to the next grid point. Repeat the design around the entire circle.

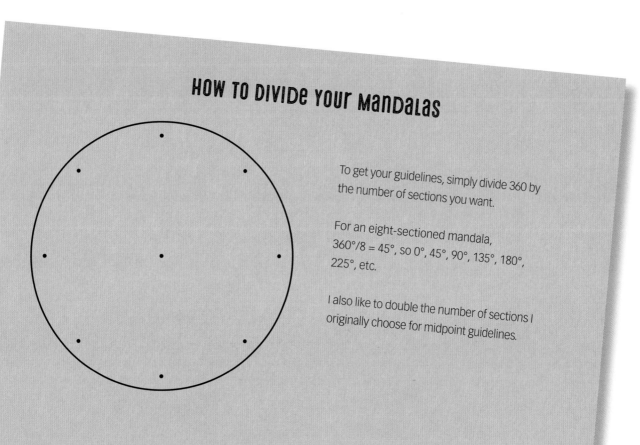

HOW TO DIVIDE YOUR MANDALAS

To get your guidelines, simply divide 360 by the number of sections you want.

For an eight-sectioned mandala, 360°/8 = 45°, so 0°, 45°, 90°, 135°, 180°, 225°, etc.

I also like to double the number of sections I originally choose for midpoint guidelines.

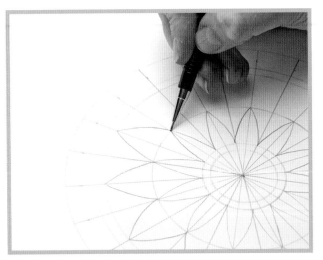

8 Build Your Design Outward

Move to the next row and draw a repeating shape around the entire circle. Here I used the same flower petal shape. Notice how I've alternated the placement of the flower petals in this row with the previous row. Feel free to mix and match the shapes that you use to create your repeating patterns.

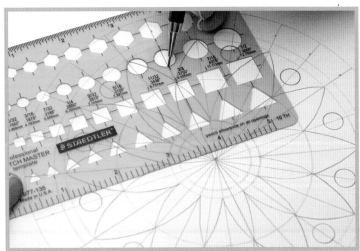

9 Use a Stencil to Add a New Row of Shapes

For the third row, use a stencil to draw circle shapes on every other guideline. Line up the stencil on the guidelines to keep your design symmetrical.

I also like the look of a hand-drawn design within a carefully measured grid. The little imperfections add character and charm.

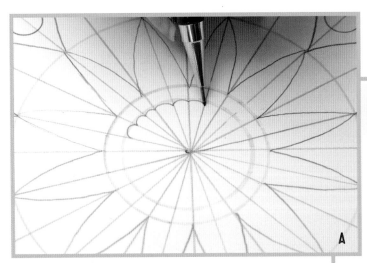

A

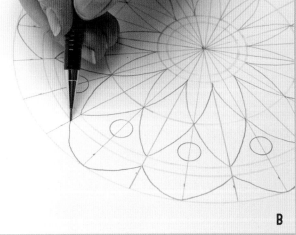

B

10 Follow Your Instincts

Continue working to develop your mandala. Here I embellished the center with small bumps around the outer edge of the inner circle, then added another outer row of wide petal shapes.

I didn't plan out the design for this mandala. I started in the center and worked my way around until I filled the mandala with various shapes. It is fun to work this way as the mandala emerges before your very own eyes.

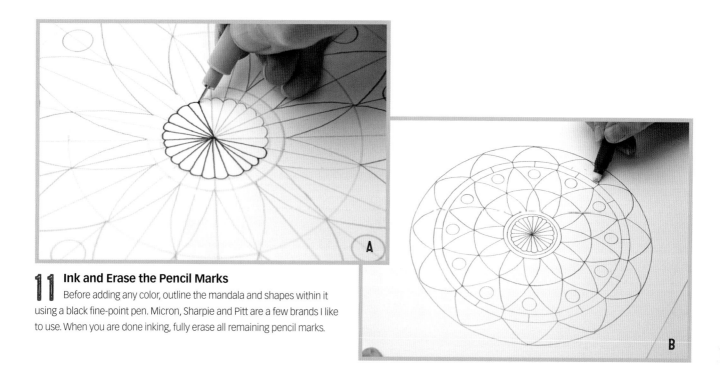

11 Ink and Erase the Pencil Marks

Before adding any color, outline the mandala and shapes within it using a black fine-point pen. Micron, Sharpie and Pitt are a few brands I like to use. When you are done inking, fully erase all remaining pencil marks.

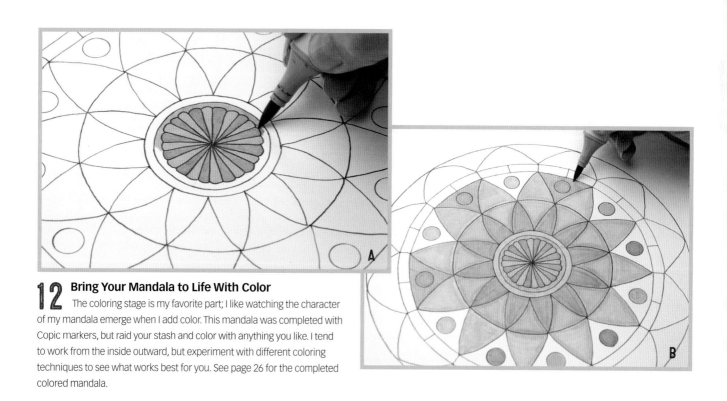

12 Bring Your Mandala to Life With Color

The coloring stage is my favorite part; I like watching the character of my mandala emerge when I add color. This mandala was completed with Copic markers, but raid your stash and color with anything you like. I tend to work from the inside outward, but experiment with different coloring techniques to see what works best for you. See page 26 for the completed colored mandala.

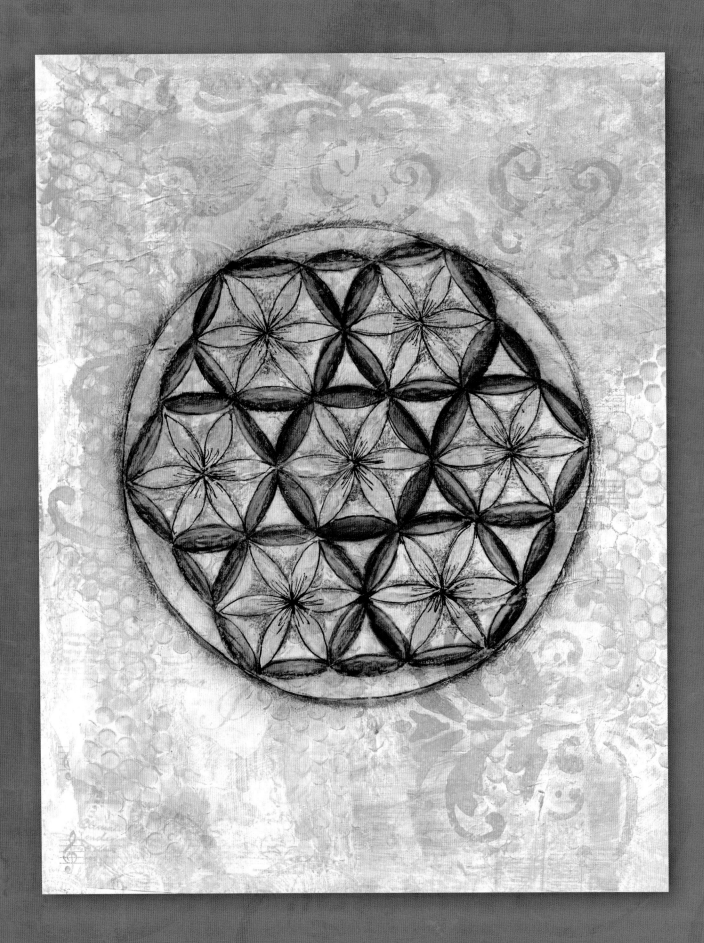

3 | Sacred Geometry

AS FAR BACK AS 3000 BC, man has been exploring the world around him using the language of math. With each measurement, ratios have been calculated, relationships observed and patterns unfolded. Take for example the Fibonacci sequence, which is related to the Golden Ratio. It starts like this: 1, 1, 2, 3, 5, 8, 13, 21, 34, 55 and so on forever. Each number is the sum of the two numbers before it. What may look like a playful mathematical exercise is an incredibly fascinating pattern that can be seen again and again in nature, music and architecture. Here are just a few examples: flower petals, sunflower heads, pinecones, nautilus shells, weather patterns, spiral galaxies and even the proportions of where the eyes, nose and mouth are placed on the human face.

In this chapter, we will explore two classic forms in sacred geometry. I'll show you how to "walk your compass" along the path of a circle to create the Seed of Life. It begins with drawing a circle and then walking around it, drawing six interlocking circles of the same size. The Seed of Life is the primary form in sacred geometry from which many other intricate-looking designs are created. In the second demonstration we'll continue our circular walk around the Seed of Life to create my favorite pattern, the Flower of Life. The final design may look complicated, but once you get the pattern, you'll see just how this intriguing mandala is both simple and complex all at the same time.

"Making a mandala is a discipline for pulling all those scattered aspects of your life together, for finding a center." —Joseph Campbell

◄ **Mixed-Media Flower of Life Mandala** | Kathryn Costa
Markers and charcoal on painted paper background

SEED OF LIFE MANDALA

AFTER COMPLETING THE PROJECTS IN THIS CHAPTER, your compass skills are going to get really good. You will be drawing a lot of circles. It is important to have a good quality compass that will hold its position. If you are just getting started with using a compass, practice drawing circles using inexpensive paper. Start with the Seed of Life before moving on to the Flower of Life.

MATERIALS LIST
..

paper of your choice

pencil or fine point pen

compass

coloring tools

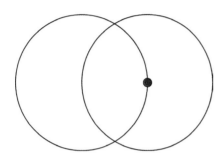

1 Draw a 4" (10cm) circle in the center of your page. For this demo, I used 9" × 12" (23cm × 30cm) bristol board. Keeping your compass set at the same length, pick a point on the circumference of the first circle and draw a second circle. The second circle will pass through the center of the first circle.

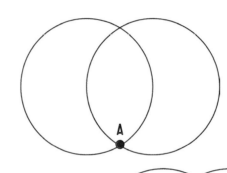

2 With your compass at the same 4" (10cm) setting, place the needle of your compass on one of the two intersection points (A) and draw a third circle. This creates a new intersection (B) where I place the needle of my compass to draw the next circle.

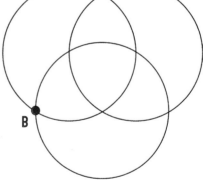

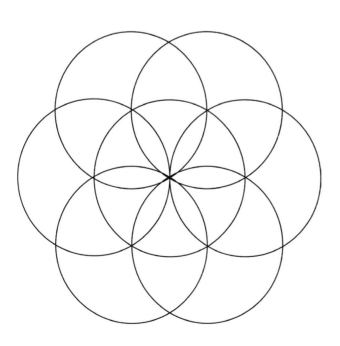

3 Repeat the process of drawing circles at each new intersection point until you have six circles surrounding the first one. This is the basis of the Seed of Life mandala. Now you are ready to add color!

BLENDING MARKERS

CHAMELEON PENS ARE MARKERS that can be used to create a blended gradient of varying tones of one color. They come with two tips, one at each end, and a mixing chamber that blends alcohol with pigment. The brush tip works like a paintbrush and the bullet tip is good for small areas.

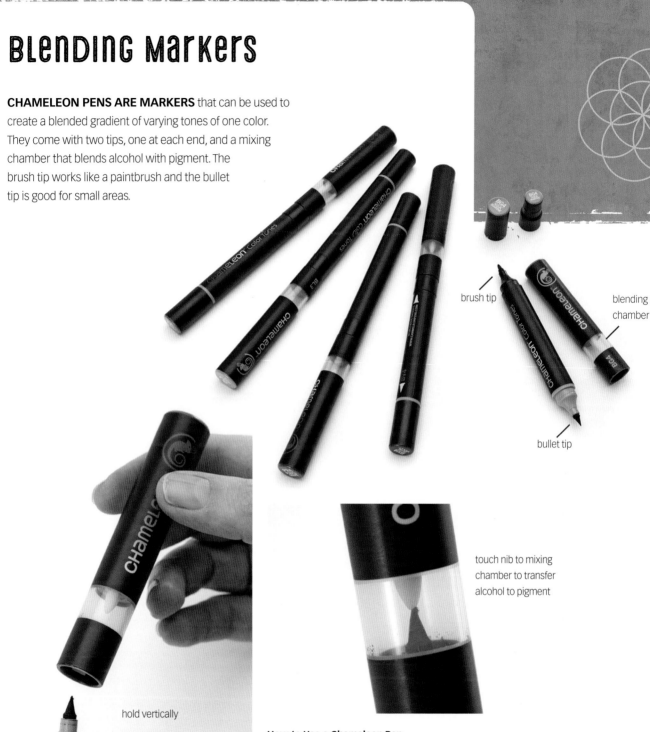

brush tip

blending chamber

bullet tip

touch nib to mixing chamber to transfer alcohol to pigment

hold vertically

How to Use a Chameleon Pen

Select the tip you want to use and place the mixing chamber over the tip. Hold the pen in a vertical position with the white mixing tip pointing down. Touch the marker nib to the chamber to transfer alcohol to the marker tip to "clear" the ink. For larger areas, keep the blending chamber on longer. It takes some trial and error to know how long to apply the blending chamber. For smaller shapes, up to 5 seconds; for larger shapes, up to 20 seconds.

Color a Gradient with Markers

USING THE CHAMELEON PENS DESCRIBED ON THE PREVIOUS PAGE, color a gradient in each section of a Seed of Light mandala going from light to dark. This creates the effect that the center is the source of light.

MATERIALS LIST

- bristol board
- black permanent marker
- blending marker pens
- white gel pen

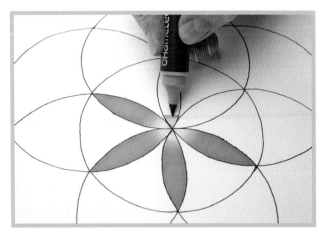

1 Remove the blending tip of the Aqua Marine pen. Hold the nib in the mixing chamber for about 5 seconds for each inner petal. Using even strokes back and forth, move the marker in a consistent motion to apply color. Work from side to side until the shape is filled. The color of the marker will change from light to the original color with a gradation of different tones.

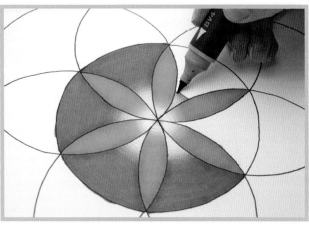

2 Select the Blue Violet pen and continue painting your mandala with gradual side-to-side strokes. For the medium section I held the nib in the mixing chamber for about 10 to 15 seconds. For best results, don't lift the marker off the page until you are finished coloring.

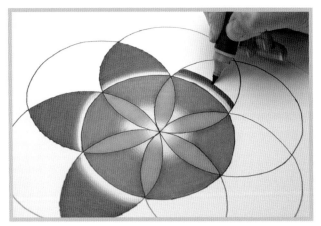

3 Use the Deep Violet pen to blend the next layer. For these large shapes I held the nib to the mixing chamber for about 20 seconds for each section.

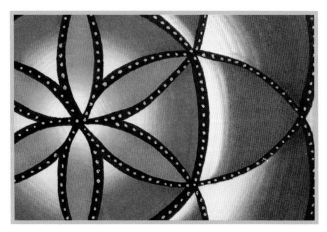

4 For the finishing touches, outline the design using a black permanent marker and add dots using a white gel pen.

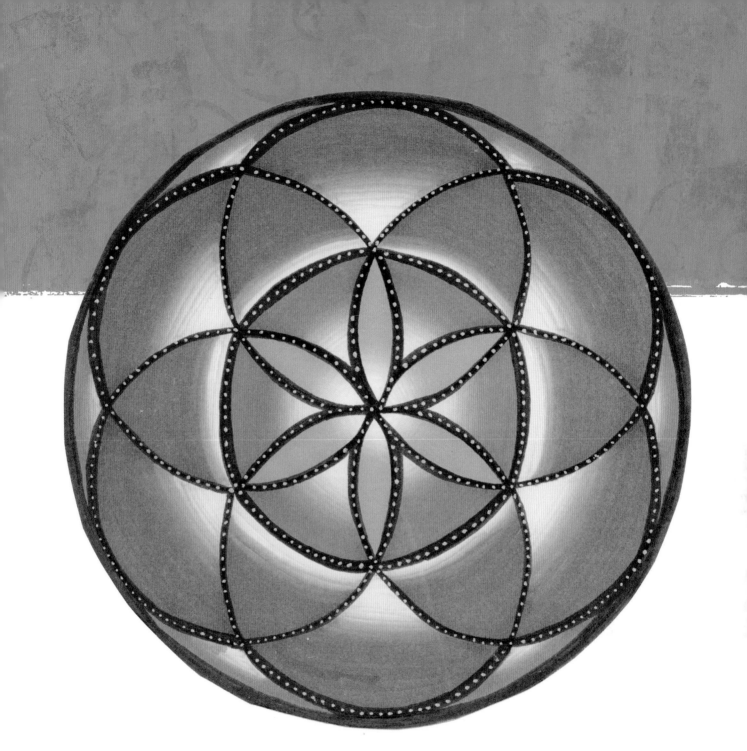

A Universal Symbol of Creation
The Seed of Life shows up throughout many Christian churches, synagogues, Kabbalah texts, ancient temples and archeological sites such as the Osirian Temple in Abydos, Egypt. The Seed of Life appears in all of the main religions, and is used by occultists and mystics alike.

Seed of Life | Kathryn Costa
Blending markers on bristol board

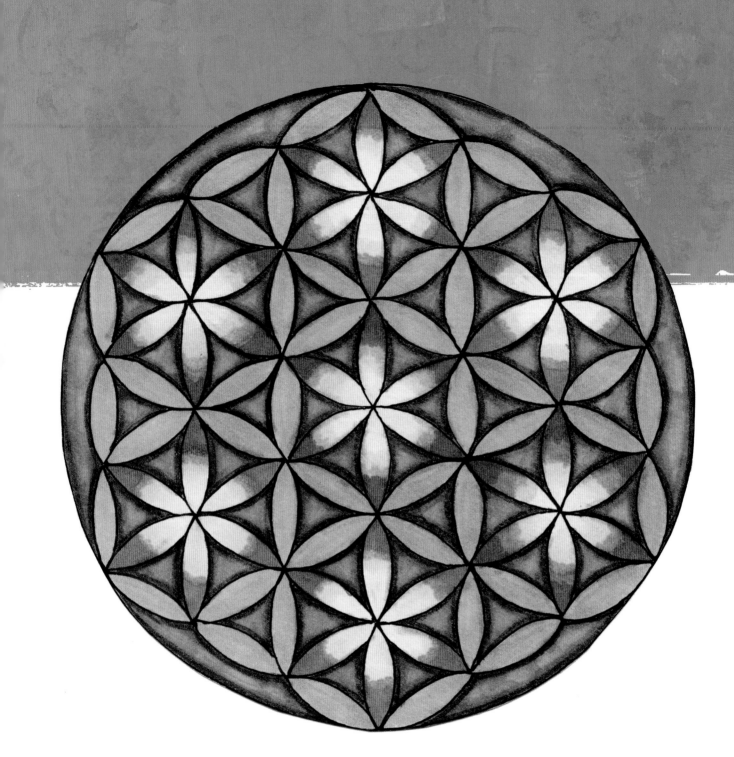

Blending with Alcohol-Based Markers
I used Copic blending markers to color this mandala: Water Lily, Begonia
Pink, Ice Ocean, Smoky Blue as well as charcoal for a finishing touch.

Flower of Life | Kathryn Costa
Blending markers and charcoal on bristol board

FLOWER OF LIFE MANDALA

IT IS QUITE AMAZING TO WATCH THE FLOWER OF LIFE pattern emerge from under the compass. We begin with the Seed of Life and continue our circular walk by drawing circle after circle. The Flower of Life is a metaphor illustrating the connectedness of all life and spirit within the universe. As you draw this form, consider each circle as representing all the people, plants, animals and everything that exists. With each rotation of your compass consider how your actions "come full circle" and impact not only your own life but everything to which you are connected.

MATERIALS LIST

- bristol board
- pencil and eraser
- compass
- black fine point pen
- markers

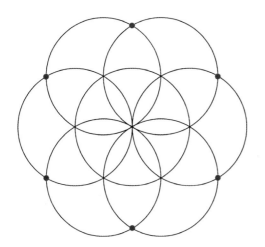

1 Start with a Seed of Life illustration (see page 34) where each circle is 1½" (4cm). Use a pencil to lightly mark a dot at the six intersection points on the outermost boundary. Place the needle of your compass on these points and draw six more circles. It is important that each circle is the same size throughout this exercise. Be sure that your compass is locked into place.

2 Mark a dot on the six new intersection points that are along the boundary. Place the needle of your compass on these points and draw six more circles.

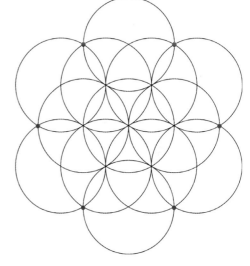

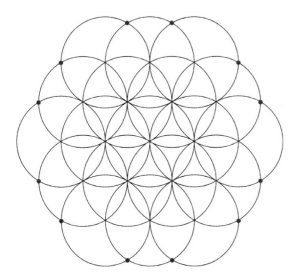

3 The design now has twelve intersection points along the boundary. As before, mark each of these intersection points with a dot and draw twelve circles.

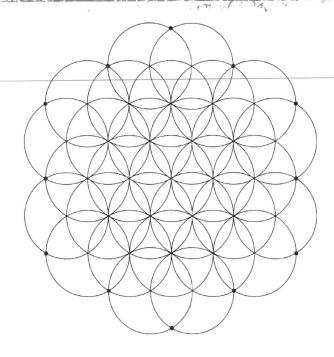

4 Mark a dot on each of the twelve new intersection points along the boundary. Place the needle of your compass on these points and draw twelve more circles.

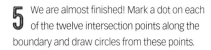

5 We are almost finished! Mark a dot on each of the twelve intersection points along the boundary and draw circles from these points.

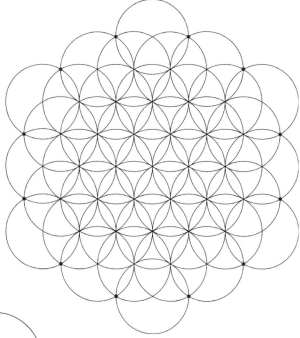

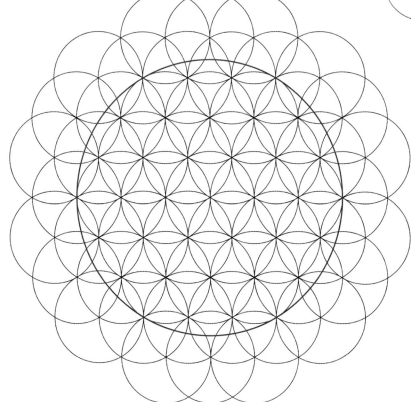

6 Change the length of your compass to draw a 6" (15cm) circle around the design. You'll see three Seed of Life patterns across the middle.

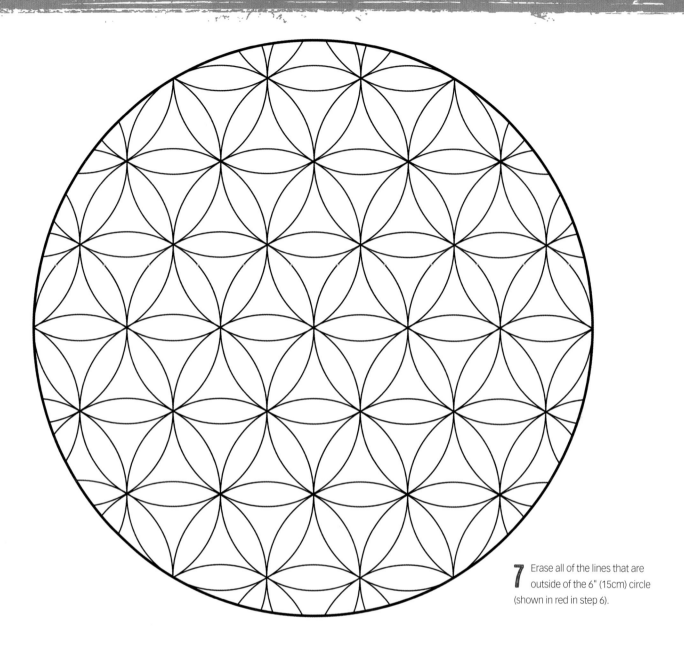

7 Erase all of the lines that are outside of the 6" (15cm) circle (shown in red in step 6).

8 Erase all of the incomplete arcs that run along the inside edge of the circle. Congratulations! You have completed the Flower of Life mandala. To finish, color in your mandala with the tools of your choice. See my finished piece on page 38.

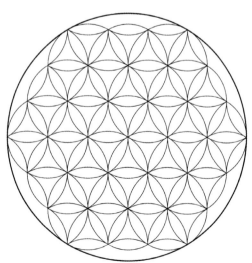

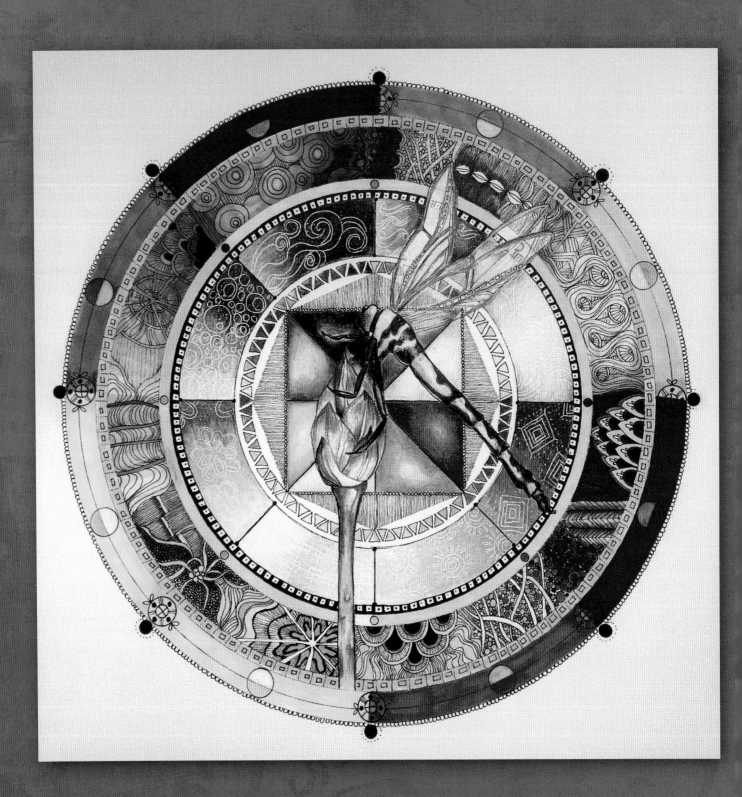

4 | PATTERNS, FILLERS & EMBELLISHMENTS

"LOVE IS IN THE DETAILS!" exclaimed my husband, an artist, as he admired Jackie Fuller's gorgeous mandala with the dragonfly perched on a lotus blossom (pictured on the facing page). Take a closer look at Jackie's mandala and you'll see many examples of repetition at work. Mandalas often have shapes and spaces that are perfect containers for adding detail. In Jackie's mandala, we see the spaces filled with a variety of shapes and lines, each repeated over and over. Another way to build a mandala is to repeat a shape along a line. Here we see rows of triangles, squares and rectangles, which on their own seem simple, but add detail and interest within the mandala.

In this chapter I'll show you how to draw 6-petal, 9-petal and 12-petal mandalas. The petals in these mandalas are spaces for you to experiment by adding repeating patterns. If you feel that the shapes in your mandalas are flat, refer to this chapter for ideas on how to use decorative outlines, hatching and stippling patterns to add interest and depth.

> "You can't use up creativity. The more you use, the more you have." —Maya Angelou

◀ **Light and Dark Mandala** | Jackie Fuller
Ink, markers and colored pencils on heavyweight grain paper

6-PETAL MANDALA

THE 6-PETAL MANDALA is another pattern from sacred geometry. Just as we "walked a circle" with our compasses to create the Seed of Life and Flower of Life, we will walk again, only this time we'll draw arcs in place of circles. We'll start our walk here with the 6-petal design and then add to it to create the next two flower mandalas in the following demonstrations.

1 Draw a circle using your compass. Be sure to keep your compass locked to the same distance throughout the following steps. Place the compass needle on any point on the circumference of the circle and draw an arc connecting one side of the circle to another.

2 Place the compass needle on one of the intersecting points and draw another arc.

3 Repeat step 2 four more times until you have drawn a 6-petal flower.

4 Stop here and fill in with colors and patterns or continue on to draw a 12-petal flower (see page 46).

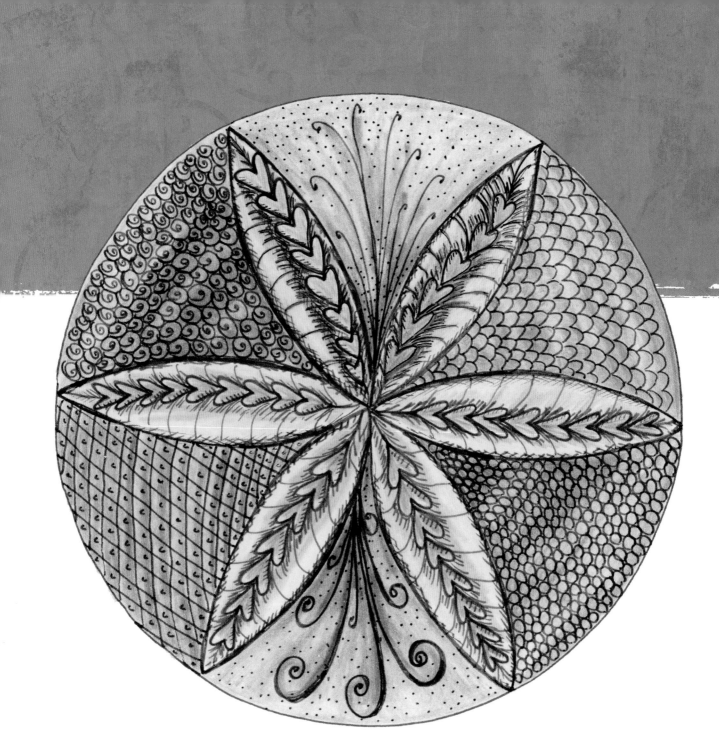

PATTERN PLAY

I began filling in the petals in this mandala with a single row of hearts. Hatching and crosshatching (see page 50) add a sense of depth to the petals and the hearts. The large areas around the petals are broken up by repeating shapes. Notice how the different patterns form by repeating very simple shapes. Prismacolor colored pencils were used to add color.

Sea Star Mandala | Kathryn Costa
Colored pencil and marker on a journal page

12-PETAL MANDALA

OUR WALK AROUND THE CIRCLE becomes more of a swing dance as we continue adding petals to the 6-petal mandala to create the 12-petal mandala.

1 Follow the directions on page 44 to draw a 6-petal flower. Place the compass needle halfway between any two petals and draw an arc.

2 Where the new arc has intersected, place your compass needle and draw another arc. Here we repeat the same process as we did in drawing the 6-petal flower.

3 Repeat the steps until you've added 6 more petals for a total of 12 petals.

4 You may stop here and fill in with colors and patterns or continue on to draw a 24-petal flower.

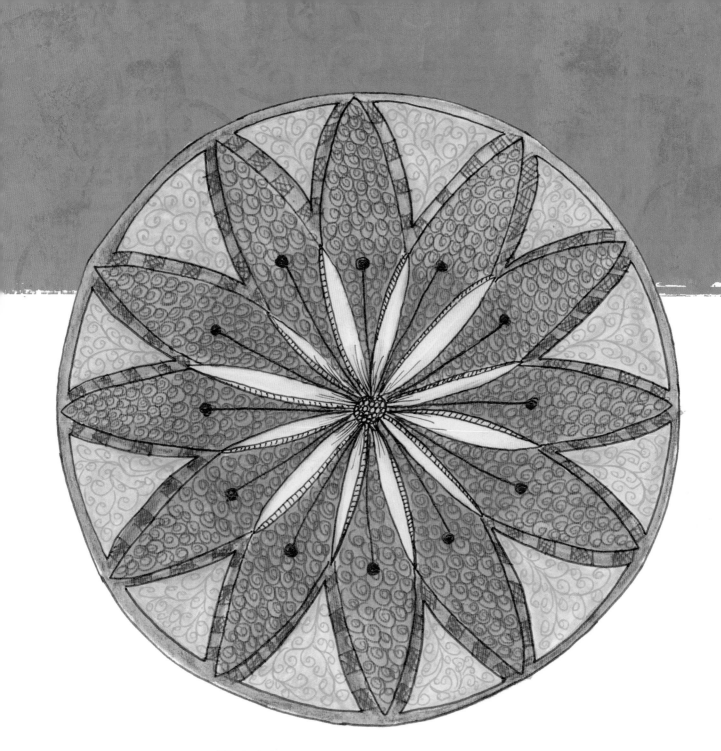

CREATING JOY

While I love professional-grade art supplies, I also have fun with just about anything that I can color or make a mark with. In this mandala, highlighters, Sharpies, colored ballpoint pens and a black fine-liner pen come together to create a vibrant and joyful mandala. Don't be shy about the materials you have on hand. Anything is fair game.

Juicy, Joyful Mandala | Kathryn Costa
Assorted markers and ballpoint pens on a journal page

24-PETAL MANDALA

THIS SWING DANCE LESSON is just about over. Shall we dance another round or two? From the 12-petal mandala we create the 24-petal mandala by swinging around the circle two more times. I promise, you won't get dizzy, but I guarantee you will get better using your compass when you finish this mandala pattern.

MATERIALS LIST

paper of your choice

pencil and eraser

compass

black fine point pen

coloring tools

1 Start with a 12-petal mandala and place your compass needle halfway between any of the two petals. Draw an arc.

2 Repeat this process until you have a 24-petal mandala.

3 You may want to erase some of the overlapping lines before coloring and filling in with patterns.

PATTERN INSPIRATION

For inspiration look to decorative motifs of Islamic art and many of the folk art designs of Eastern Europe, Russia and India.

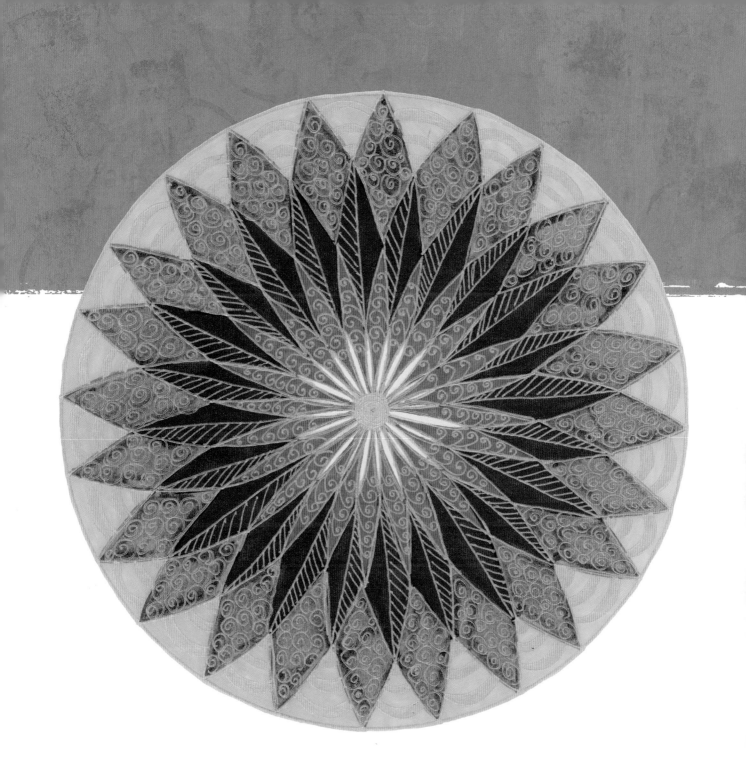

ILLUMINATED MANDALAS

Gold and silver gel pens can add a touch of glamour to your mandala art. Here a combination of Sharpie and Crayola markers were used for the background color. These simple materials were elevated by the addition of sparkly gold patterns drawn in with gel pens.

Putting on the Ritz | Kathryn Costa
Assorted markers and gold gel pen on a journal page

ADDING EMBELLISHMENTS

QUICKLY TRANSFORM a flat-looking mandala by drawing fine parallel lines (hatching), overlapping lines (crosshatching), or repeating dots (stippling) along or in between the shapes. The density—how close or far apart the lines or dots—will create a sense of depth.

hatching crosshatching stippling and dots

Before and After
Compare and contrast these two mandalas. Notice how the details make the second mandala much more interesting.

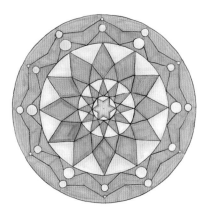

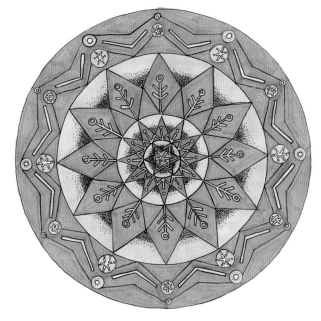

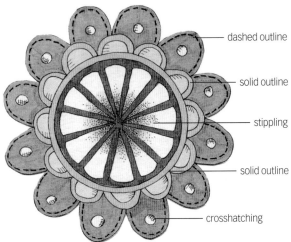

dashed outline

solid outline

stippling

solid outline

crosshatching

Outline Your Mandalas
In addition to hatching, crosshatching and stippling, outlining is a great way to embellish your mandalas. The outline can be solid, dashed, dotted or scalloped. Use these marks in between or along shapes to add depth and vary the tone.

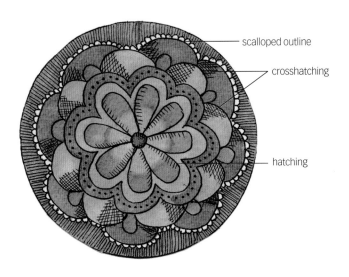

scalloped outline

crosshatching

hatching

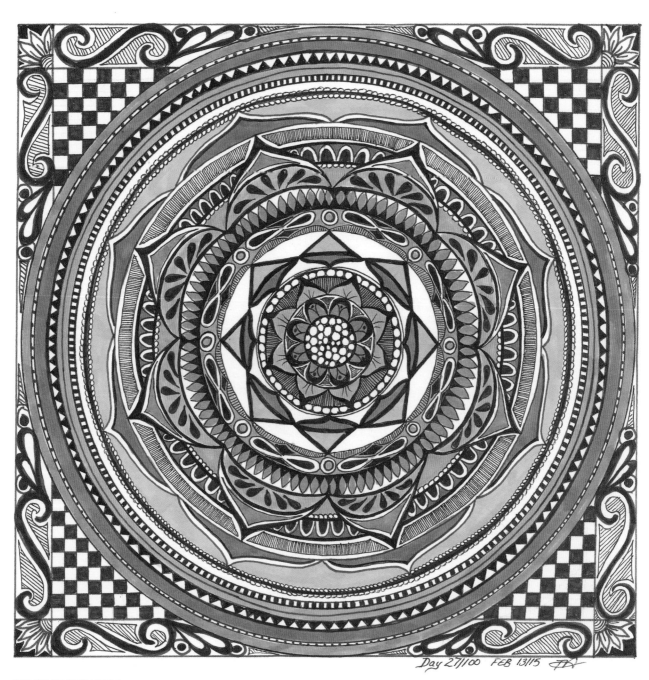

Day 27/100 FEB 13/15

IT'S ALL IN THE DETAILS

Imagine Tara's mandala without all of the patterns. The details take a pretty mandala to another level of awesomeness. I invite you to spend a little time with this mandala. Start from the center and work your way outward. You'll find another masterpiece from Tara in the gallery section on page 141.

Sunshine | Tara Asuchak
Blending markers and white ink on mixed-media paper

pattern inspiration

ADD BEAUTIFUL DETAILS TO YOUR MANDALAS by filling in the shapes
with repeating patterns. Refer to the patterns here for ideas and inspiration
that you can use in your mandala art.

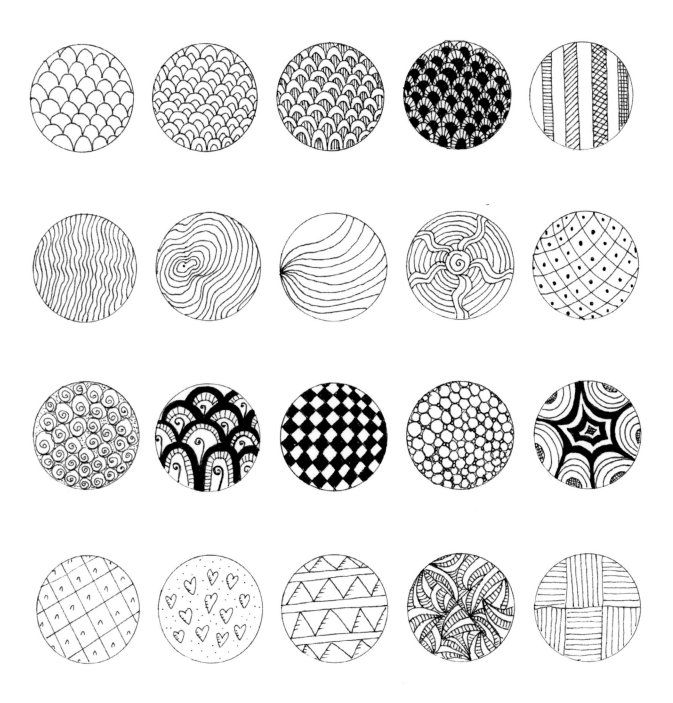

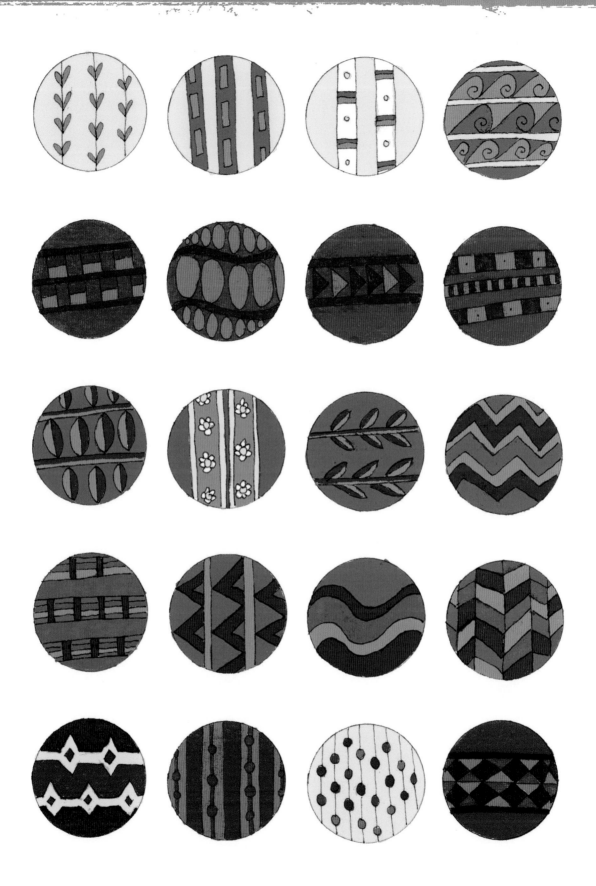

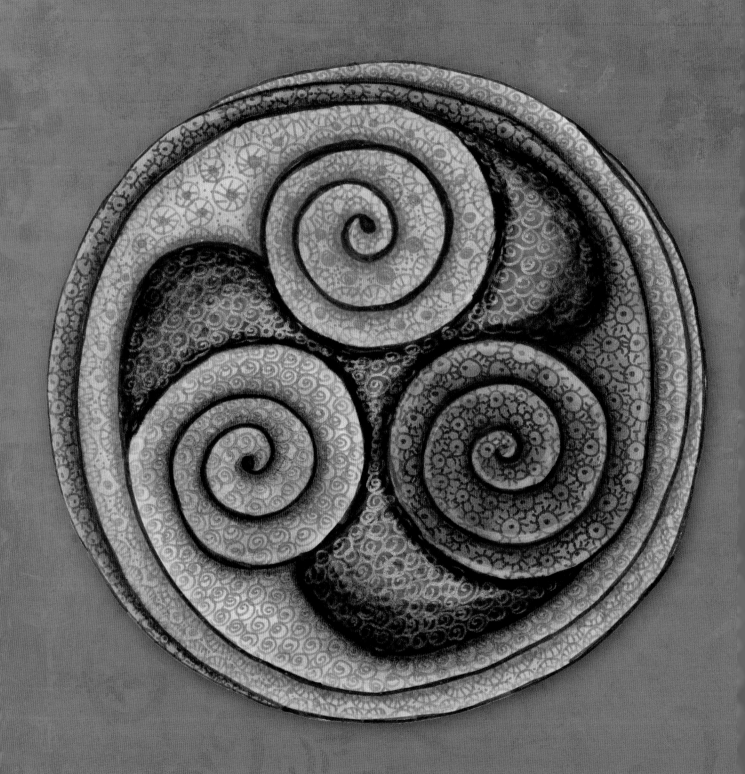

5 | CELTIC SPIRALS

BEFORE WE BEGIN OUR STUDY OF SPIRALS, let's get grounded with a spiral mini meditation. Take a moment to trace a spiral with your finger on this page. With your eyes closed, start at the center and wind your finger around and around until you get to the edge of the page. Repeat this motion again; this time, however, let out a deep breath as you trace your imaginary spiral. Feel your body relax and unwind. Continue to trace spirals alternating between clockwise and counterclockwise directions until you feel completely relaxed.

The spiral is a symbol that has many meanings. As in our spiral meditation just now, the spiral can symbolize letting go and surrendering. The spiral is also about connectivity as we look within and without, making connections between who we are and those around us. Similarly, the revolutions of time, stars and planets all move in a spiral pattern.

The most intricate spirals are those found in Celtic design. The word *Celtic* refers to the people who lived in Britain and Western Europe from 500 BC and AD 400. While spirals show up in many cultures, those spirals bear only a single coil, whereas two, three or more coils appear in the Celtic spirals.

To begin your study of Celtic spirals, practice the six different spiral designs found on the following pages. After you get the hang of drawing the 2- and 3-coiled spirals, pull them together within one mandala.

"Creativity requires faith. Faith requires that we relinquish control." —Julia Cameron

◄ **Gathering of Three Friends** | Kathryn Costa
Markers, gel pens and pastels on a journal page

2-COIL SPIRALS

TO CONSTRUCT THE 2-COIL SPIRALS, begin by drawing a circle. In a line through the center of the circle, follow the diagrams below to mark several dots. For each style I always start with the center dot and then work my way outward. Follow the red lines in each diagram to build the spiral pattern. Use a pencil to practice drawing these forms. It takes some practice but once you get the hang of it, your lines will flow naturally.

MATERIALS LIST

drawing paper for practicing

bristol board for final piece

pencil and eraser

ruler

compass

protractor

circle stencil

black fine point pen

markers

charcoal pencil

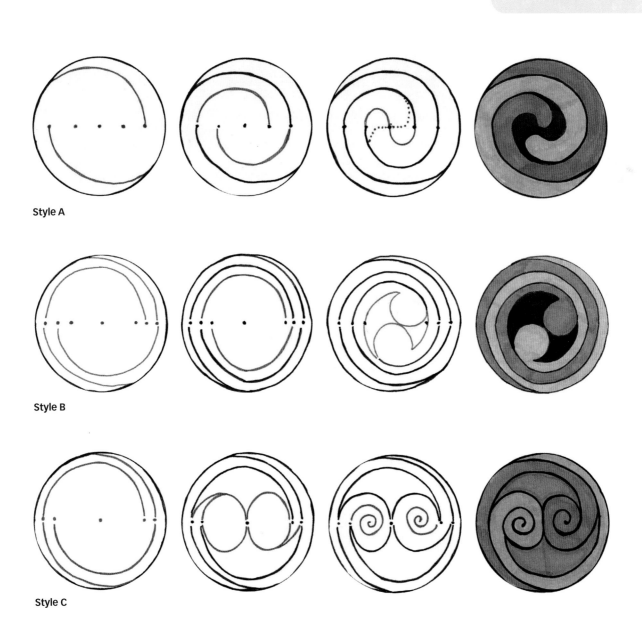

Style A

Style B

Style C

3-COIL SPIRALS

START DRAWING THE 3-COIL SPIRALS as we did for the 2-coil by drawing a circle and marking guide points with dots. When you are just learning how to draw these patterns, I recommend working larger than the diagrams pictured here; 3" or larger (7.5cm) is a good size. If you want to learn how to draw Celtic knotwork and other spiral designs, I recommend *Celtic Art: The Methods of Construction* by George Bain.

MATERIALS LIST

drawing paper for practicing

bristol board for final piece

pencil and eraser

ruler

compass

protractor

circle stencil

black fine point pen

markers

charcoal pencil

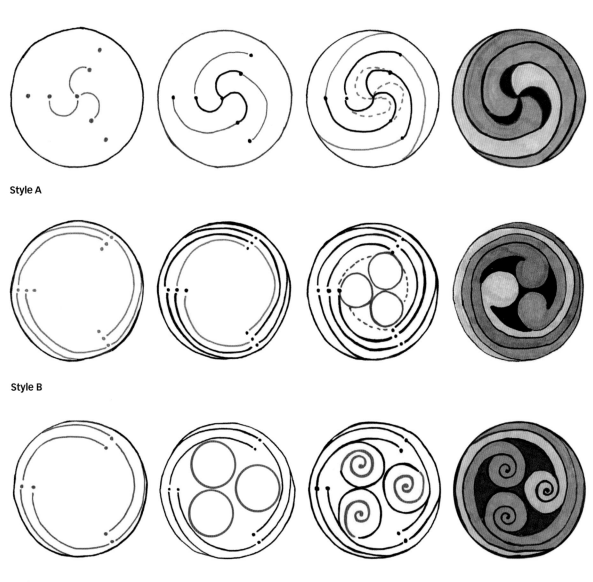

Style A

Style B

Style C

MaNDaLa WITH several CELTIC SPIRaLS

LET'S PULL TOGETHER WHAT YOU'VE LEARNED to create a mandala with several interconnected Celtic spirals. As you draw each spiral, think about the people and events in your life and how everything is interconnected. At any time, if you are feeling tense or wound up, pause for a moment and follow the spiral meditation instructions at the beginning of this chapter.

MATERIALS LIST

drawing paper for practicing

bristol board for final piece

pencil and eraser

ruler

compass

protractor

circle stencil

black fine point pen

markers

charcoal pencil

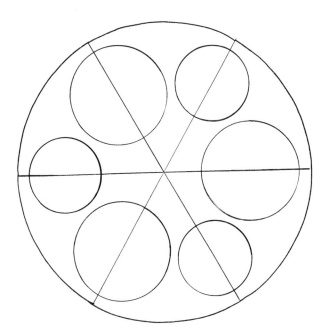

1 Draw a 6" (15cm) circle with your compass and divide it into six segments using your protractor. (See page 27 to review the grid method of drawing a mandala.) Draw three 2" (5cm) circles alternated by three 1½" (4cm) circles. A circle stencil makes it easy to draw small circles.

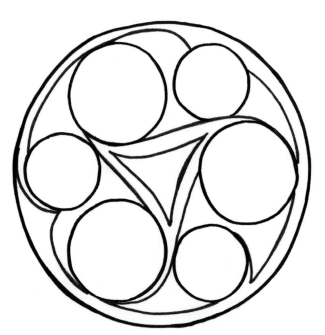

2 Using a pencil, lightly draw connecting lines from the smaller circles to the larger ones.

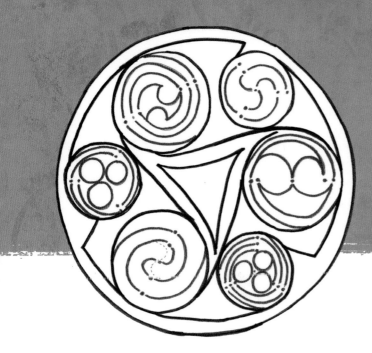

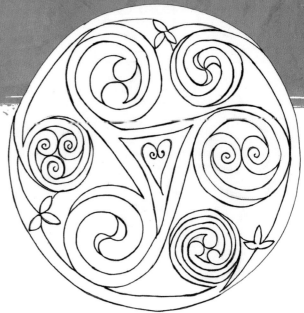

3 Refer to the Celtic spiral instructions on pages 56–57 to draw a spiral in each circle. In this example I drew one of each. You may have a favorite spiral or one that is easier for you to draw. Mix and match the spiral designs.

4 Use a fine point black pen to draw over the pencil lines. Once the ink has dried, gently erase the pencil marks.

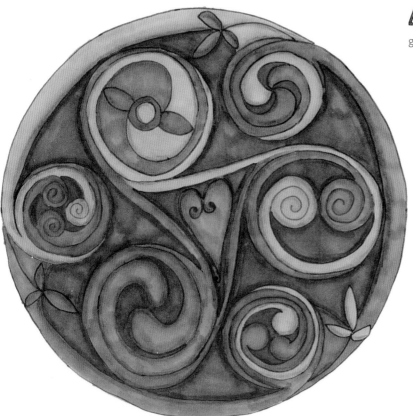

5 Color your mandala. For a finishing touch, outline the mandala with charcoal and use a blending stump to soften the charcoal lines. This Celtic design is based on nature, so I chose to work with earth-toned markers, specifically, Prismacolor Art Markers' Terra Cotta, Goldenrod, Bronze Green and Gray.

Celtic Spiral Mandala | Kathryn Costa
Markers and charcoal on bristol board

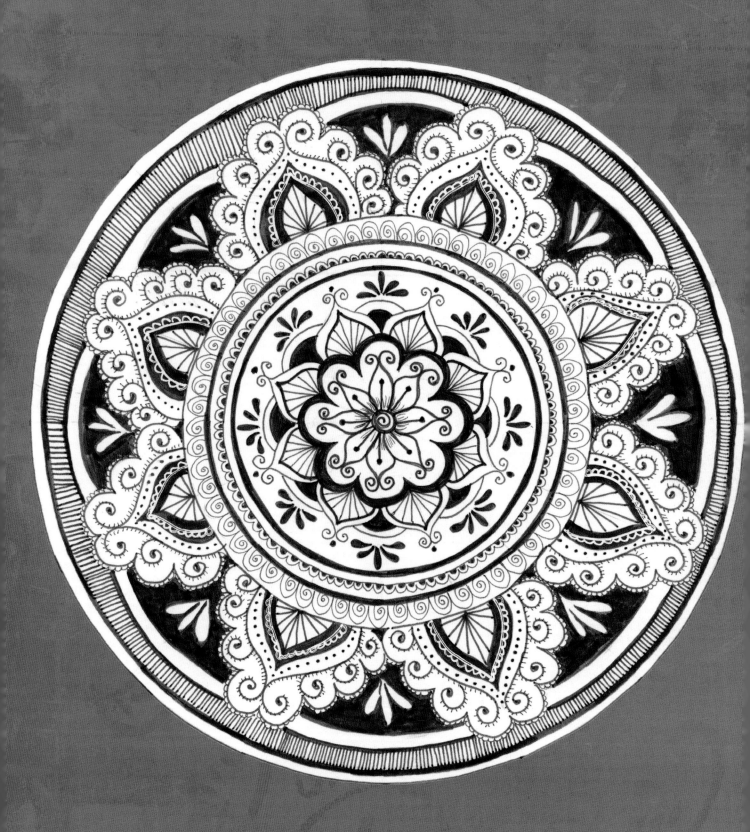

6 | MEHNDI MANDALAS

THE ART OF HENNA, OR MEHNDI as it is commonly referred to, is the practice of creating temporary tattoos using the dye from the henna plant. This art form dates back over 5,000 years and the symbols serve as symbols of good luck, health and sensuality in India and the Arabic world.

Fascinated by this art form, I started my research by creating a Pinterest board. After collecting a couple dozen images, I spent time studying each one in depth. In my journal I copied individual design elements, noting a variety of forms including flowers, vines and scalloped edges adorned with little dashed lines or heavy dots or beads. From there I began creating my own mandala designs by mixing and matching the design elements. This process is a great way to learn about the design styles of a culture and how to incorporate the elements in your own art.

"Be yourself; everyone else is already taken."
—Oscar Wilde

◄ **Mehndi Mandala** | Kathryn Costa
Sepia-toned fine tip pens on bristol board

POPULAR MEHNDI SYMBOLS

THERE ARE NUMEROUS SYMBOLS IN THE MEHNDI TRADITION. The most common are flowers that are said to mean joy and happiness and the bud, which is symbolic of growth or new beginnings. Birds are thought of as messengers. As you look over the symbols and their meanings on these pages, notice how the mandala shows up as a decorative element. Consider incorporating your mandala designs into other shapes and drawings.

Hamsa hands and eyes are symbols for protection. The "evil eye" turns any evil wish back onto the gazer while offering a form of spiritual protection.

Peacocks symbolize beauty.

Swans symbolize success and beauty.

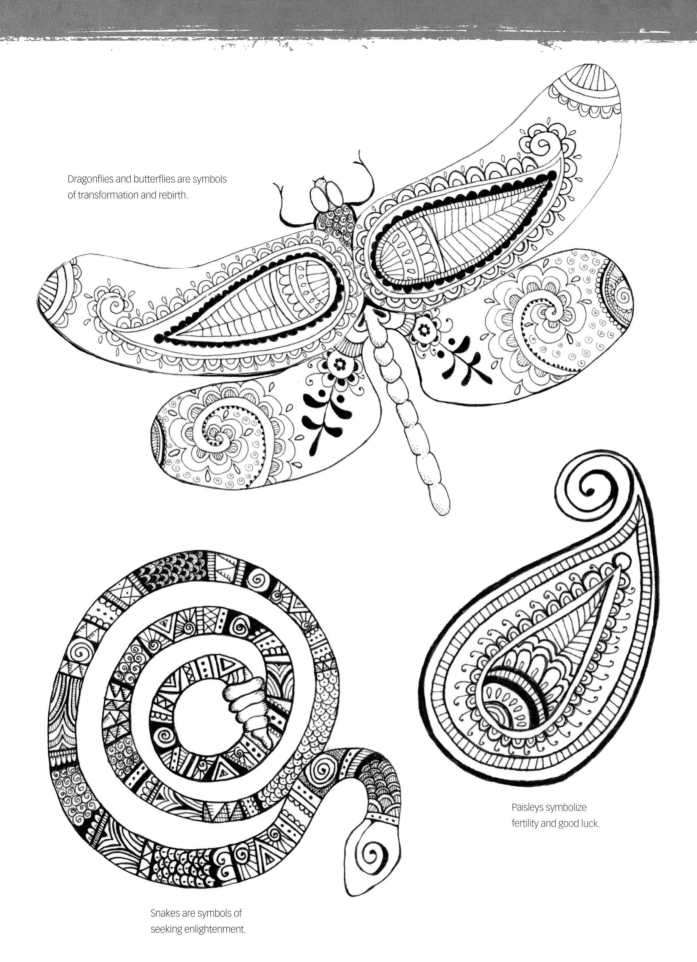

Dragonflies and butterflies are symbols of transformation and rebirth.

Paisleys symbolize fertility and good luck.

Snakes are symbols of seeking enlightenment.

MEHNDI-INSPIRED MANDALAS

CREATE YOUR OWN MEHNDI MANDALAS by drawing your mandalas freehand or using the grid method. All you need is your favorite drawing paper, and various sizes of sepia-toned and black pens. Practice the following shapes on this spread to design your own Mehndi-inspired mandalas and experiment with adding color.

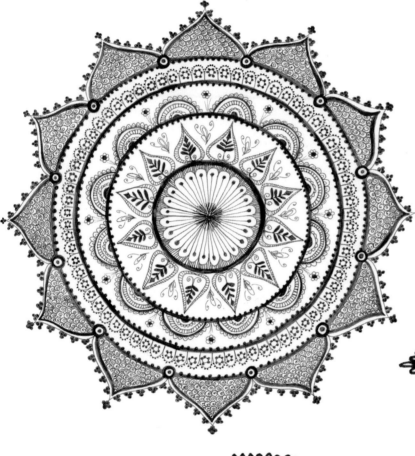

Mehndi-Inspired Mandala in Color
Kathryn Costa
Blending markers on bristol board

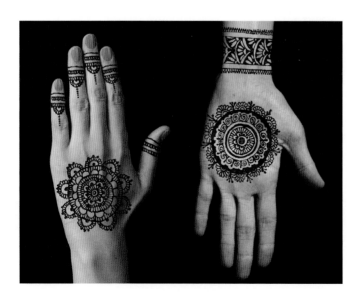

HENNA TATTOOS

Mehndi designs were traditionally drawn on hands, feet and other areas of the body. Where the henna tattoo is placed can be just as significant as the design itself. For example, a henna tattoo on the palms of the hands opens one to receive blessings in contrast to the top of the hands, which serves as a symbol of protection.

Visit **createmixedmedia.com/mandala-guidebook** to download gorgeous painted papers and more from Kathryn Costa.

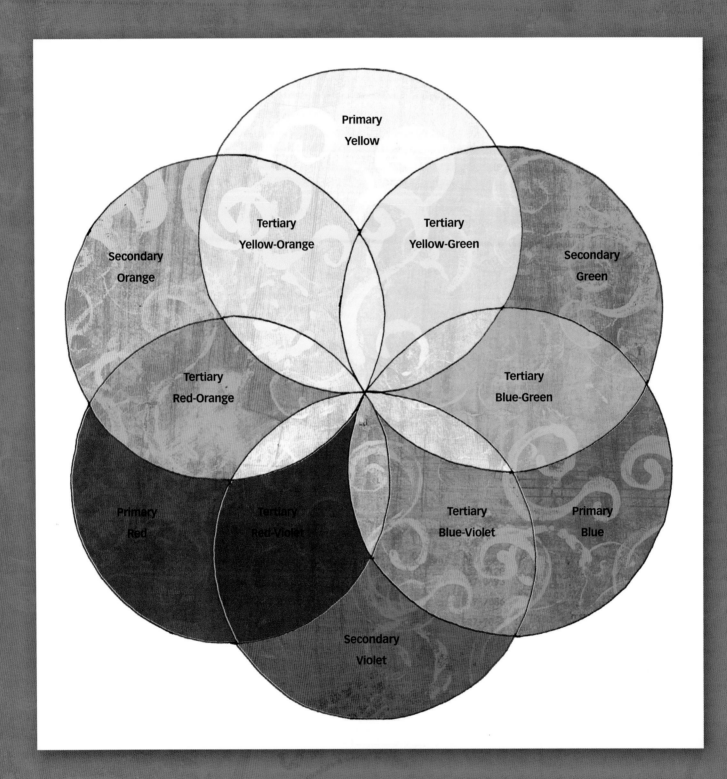

7 | PLAYING WITH COLOR

DO YOU EVER GET STUCK and can't decide which colors to pick? Do you find yourself always reaching for the same colors? Are you feeling in a color rut? This chapter explores different color combinations based on the traditional color model starting with the primary colors: red, blue and yellow.

The best way to learn about color is to color! Draw a mandala and photocopy or scan it and print several copies. Use markers, colored pencils or paint to try out different color combinations. Mixing paint and blending markers are some of the best ways to get a feel for the relationships of colors. As you study the color combinations in this chapter, refer to the color wheel on the facing page. For inspiration, look at what you are wearing and color a mandala based on the colors of your outfit. Go color shopping! I'm often inspired by package design. Go to the grocery store to get ideas on different color combinations. Stores that sell pretty linens, clothing and wrapping paper are other places to find your next favorite color combo.

"It is a happy talent to know how to play."
—Ralph Waldo Emerson

◄ **Color Wheel Mandala** | Kathryn Costa
Mixed media and digital

BASIC COLOR COMBINATIONS

HERE I'VE TAKEN THE SAME MANDALA DESIGN and colored it in different ways to illustrate the terms defined below. To create a sense of harmony in your mandalas, select a palette and use these colors throughout the design. To add a little more variety and interest, use lighter (tints) and darker (shades) colors in your palette.

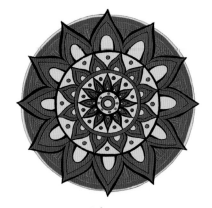

Primary
Red, Yellow, Blue

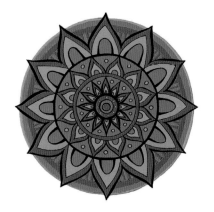

Secondary
Orange, Green, Violet

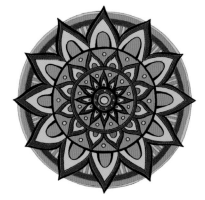

Tertiary
Violet, Yellow-Green, Blue-Green

Complementary
Red, Green

Complementary
Yellow, Violet

COMMON COLOR TERMS

Primary colors: Red, yellow and blue. These colors cannot be made from other colors and when mixed give you all of the other colors in the color wheel.

Secondary colors: These colors are made by mixing two primary colors together: orange = red + yellow, green = yellow + blue, violet = blue + red.

Tertiary colors: These colors are made by mixing one primary and one secondary color together: red-orange, red-violet, yellow-orange, yellow-green, blue-green, blue-violet.

Complementary colors: These are colors that are opposite each other on the color wheel. The combinations result in vibrant, high contrasts because the colors are farthest away from each other on the color wheel: red to green, yellow to violet, blue to orange.

Split complementary colors: Select a color and the two colors on either side of the complementary color. For example: violet, yellow-orange, and yellow-green.

Analogous colors: Two or more colors next to each other on the color wheel: red, red-orange, orange, yellow-orange or green, blue green, blue.

Monochromatics: These are tints, tones and shades of the same color. Tints are made by adding white, tones by adding gray and shades by adding black.

Complementary
Blue, Orange

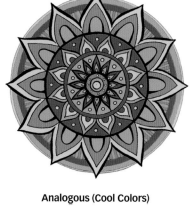

Analogous (Cool Colors)
Blue, Green, Yellow-Green

Analogous (Warm Colors)
Red, Orange-Red, Orange, Dark Red

Analogous (Warm Colors)
Yellow, Orange, Yellow-Orange

Split Complementary
Violet, Yellow-Orange, Yellow-Green

Split Complementary
Green, Orange, Red-Violet

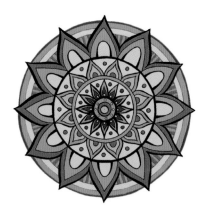

Monochromatic
Tints, Tones and Shades of Green

MIX AND MATCH COLORS

Your study of color has only just begun. After you practice the combinations pictured on these pages, continue to explore the possibilities. Take, for example, the complementary color scheme. The three examples shown here start with a primary color and are paired with the secondary color found directly across from it on the color wheel. For a beautiful variation, start with a tertiary color, say blue-green, and pair it with the color opposite on the color wheel, red-orange. Refer to the color wheel on page 66 to pick your colors. How is the blue-green and red-orange different from and similar to the blue and orange combination? Which do you prefer? Challenge yourself by working with colors you don't normally reach for. You may just discover a new favorite combination.

FOUND INSPIRATION

LOOK TO BEAUTIFUL PHOTOGRAPHS and artwork for inspiration. In the examples on this page, I created a color palette based on the colors in the photographs and then used these colors for my mandalas. All photos by Claudia Gray.

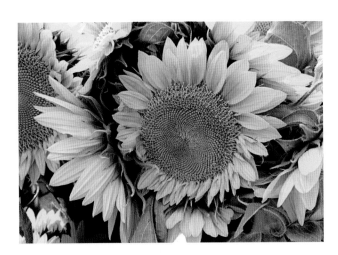

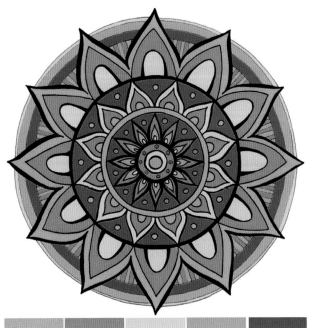

Notice how you react to colors. Take this sunflower photo; when I look at it, my heart smiles. I selected this photo to see if I could capture in my mandala the joyful feeling that I experience when looking at sunflowers.

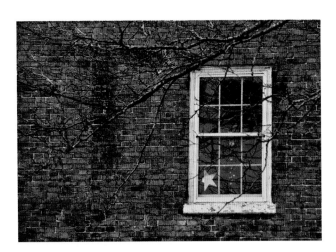

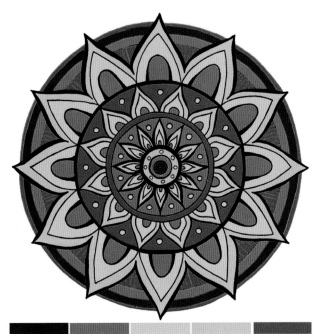

Look for subtle variations in color. If you take a closer look at the bricks, notice how many different colors, tints and shades there are in this photograph. The white frame of the window isn't entirely white; notice the bluish gray tint.

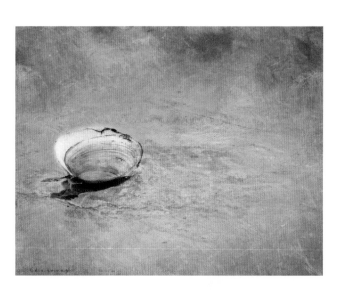

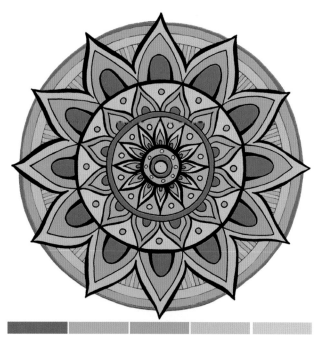

Try new color combinations. I love how Claudia alters her photos to create a painterly effect. I often use teal and blue in my mandalas. I was inspired by Claudia's blue shell photo to add gray to this palette, a color that I rarely use in my mandala art.

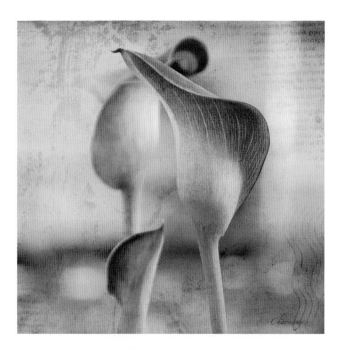

Capture a feeling or quality. This photo of a calla lily has a nostalgic, dreamy quality. I was curious to see if I could capture that timeless, vintage look in the mandala.

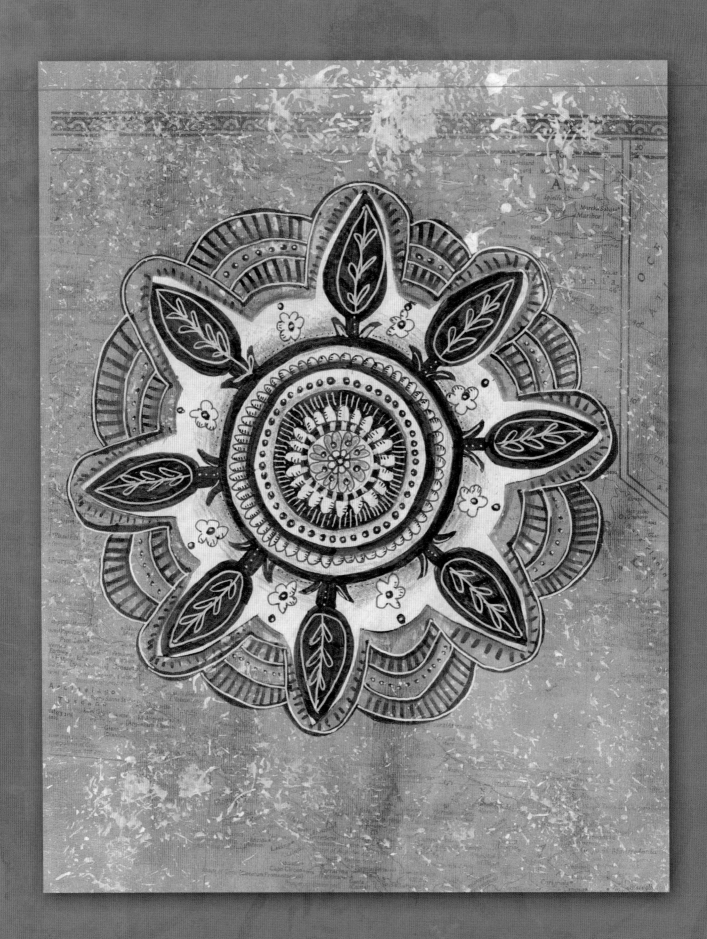

8 | PAINTED BACKGROUNDS

LET'S BREAK OUT OUR PAINTS and open up the color possibilities for our mandalas. In the earlier chapters of this book our focus has been on coloring within the lines. Creating the painted backgrounds in this chapter helps us to shift into the spirit of the way of the Tao and go with the flow. When painting, I like to get lost in the feeling of the paint when rolling it on the page or scraping something along the surface. It is a tactile and sensual process that gets me out of my head and reminds me of when I was a child and I played with abandon.

I cover two techniques for creating painted papers in this chapter: monoprinting with Gelli plates and layering paint onto paper with a variety of tools. The colorful papers that we will create in this chapter can be used as backgrounds for our mandalas or cut up and used as pieces in a collage mandala.

Unlike the process of carefully measuring a grid and drawing lines and shapes of equal size, painting papers has a way of loosening up our tendency to control the outcome. In fact, we can't control how the paint will be transferred using a Gelli plate in the first project, or how the paint, when sprayed with water and then scraped with an old credit card, will look in the second project. It can be scary to not know how the results will turn out, but it is also an exciting adventure.

"Creativity is the power to connect the seemingly unconnected." —William Plomer

◀ **Mandala on Altered Map** | Kathryn Costa
Black marker, white gel pens and colored pencils on watercolor
paper affixed to a photocopied map altered with acrylic paints

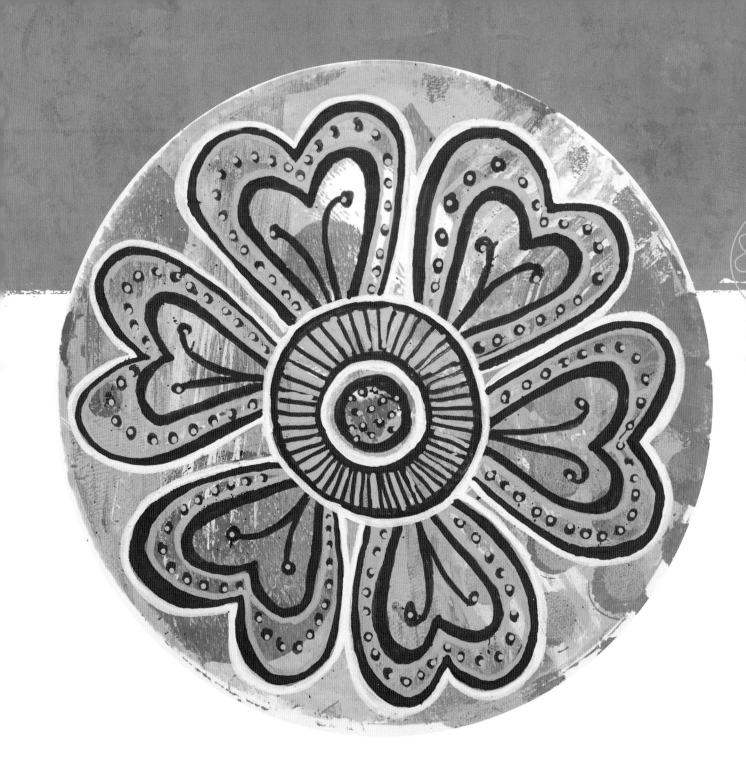

Think Contrast

Posca paint pens are one of my favorite markers when drawing and coloring over painted surfaces. They are opaque and can be used to paint over any color. For example, if I painted a mandala with a bright blue color and didn't like the result, I could paint over it with white. Likewise, if I used white, I could change that by painting the blue over it. For best results think in terms of color contrast when outlining the shapes of your mandalas. The white lines in the example above show up nicely set against the colored background. If I had used the blue color, the mandala would have become lost and disappeared into the background.

Full of Hearts Mandala | Kathryn Costa
Acrylic paints and water-based paint pens on paper

MONOPRINTED GELLI PLATE

MONOPRINTING IS A PRINTMAKING TECHNIQUE that creates one-of-a-kind prints. In this demonstration, we'll use a Gelli plate as our printing plate to create interesting backgrounds for our mandalas. When selecting paints, I get the best results with the light body versus the heavy body paints. A good example of light body paints are the inexpensive acrylics sold in craft stores that are typically used for stencilling. Be sure to have some white and light yellow paints on hand to create lighter tints of your favorite colors. These lighter tones make nice subtle backgrounds for your colorful mandalas.

MATERIALS LIST

- mixed media paper
- acrylic paints
- Gelli plate, any size or shape
- acrylic base to secure Gelli plate
- brayer
- stencils
- palette paper or freezer paper
- pencil and eraser
- paint pens

Gelli Plate and Brayer

Gelli plates come in a variety of sizes and shapes. For this demo I used the round plate. It is made of a gelatin material that is easy to use and easy to clean. A brayer is used to roll paint along the plate surface.

1 Place the Gelli plate onto an acrylic base. Here I'm using an inexpensive acrylic picture frame purchased from a craft store.

2 Squeeze some turquoise acrylic paint onto a piece of palette paper and roll your brayer through it to ink the brayer. Some people like to apply paint directly to the Gelli plate, but using palette paper helps avoid over-inking the plate.

Acrylic paints come in different grades: light body, medium body and heavy body. For creating soft backgrounds that don't compete with the mandala art, I like the inexpensive craft paints in pastel colors.

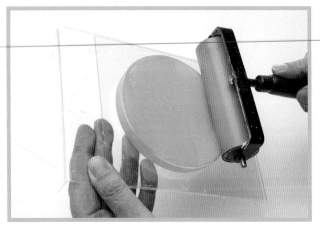

3 Apply the inked brayer paint directly to the Gelli plate and spread it over the entire surface.

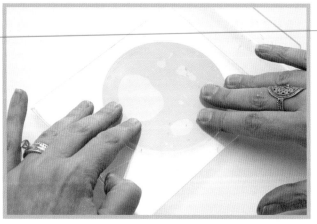

4 You are going to work on two prints simultaneously. First, firmly press the inked Gelli plate onto a piece of paper.

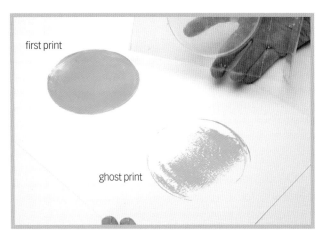

first print

ghost print

5 Remove the Gelli plate to reveal your first print, then immediately press the Gelli plate onto a second piece of paper. The second lighter print is called a "ghost print."

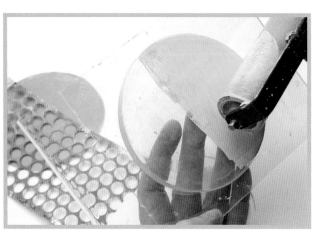

6 Roll the brayer through a contrasting color such as green and roll the paint onto half of the plate.

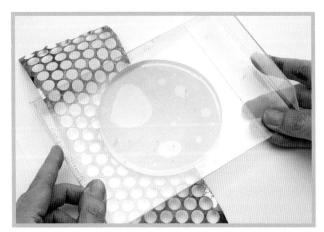

7 Place a stencil over the first print from step 5 and press the painted plate over the stencil. To keep with the circle motif, I used large punchinella, also known as sequin waste.

COLLECT STENCILS FOR TEXTURE

Stencils create interesting patterns and textures. Punchinella is one of my favorite stencils as it carries the circle motif to the printed background. It is also known as sequin waste and comes in a variety of sizes and shapes.

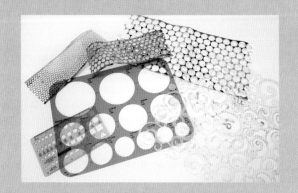

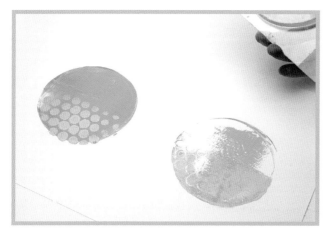

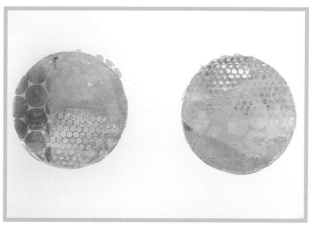

8 Remove the plate and admire the impression that the stencil left on the Gelli plate. Next, press the Gelli plate onto the ghost print from step 5 without using the stencil.

9 Continue to roll paint onto the Gelli plate and print, adding layers of color and shapes. Here I added some teal and tinted some of the colors using white.

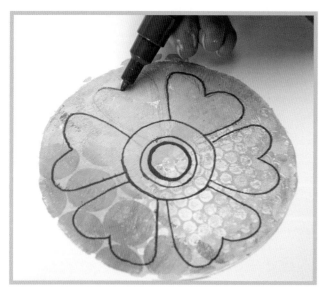

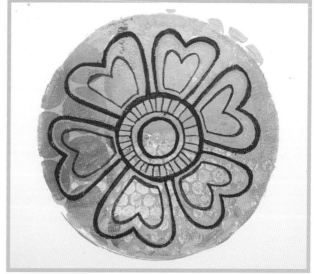

10 Once the prints have dried completely, draw a freehand mandala. It helps to first lightly draw your guidelines using pencil.

11 Use a variety of blue, green and white Posca paint pens to color the mandala design. Turn to page 74 to see my completed mandala on the Gelli plate background.

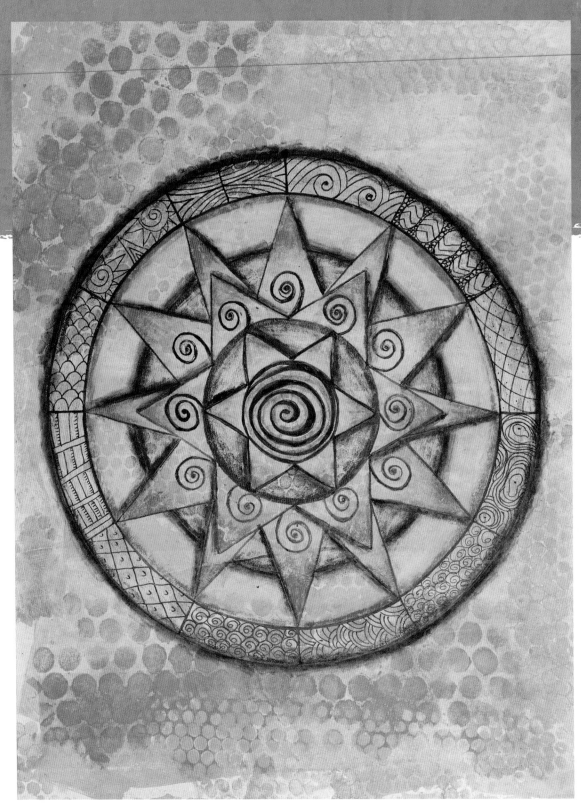

Pulling It Together

This mixed-media mandala pulls several lessons into one design. We begin by creating a painted background as demonstrated in this chapter. The mandala takes shape using the grid method from chapter 2. Colors can be selected based on color theory learned in chapter 7, and the finishing details are applied by adding patterns learned in chapter 4.

Mixed-Media Sun Mandala | Kathryn Costa
Acrylics, markers, colored pencils and charcoal on paper

painted papers

CREATING YOUR OWN CUSTOM PAPERS gives you the freedom and control to design collages and mandalas in your favorite color palettes. This technique for creating painted backgrounds doesn't require many supplies to get started; in fact, you are encouraged to work with what you already have on hand. For example, if you don't have a brayer, then scrape on paint using an old gift card. Don't have an old gift card? Try cutting a piece of stiff cardboard. The netted bags that fruit comes in work as a good stencil. The end of a cardboard toilet paper roll can be used as a circle stamp. Scrunching up paper towels to pounce paint is a good alternative to using a makeup sponge. You don't have to make a big investment in tools and supplies to get interesting results.

MATERIALS LIST

- paper
- acrylic paints
- brayer
- old gift card
- makeup sponge
- paper towel
- ink sprays
- stencils
- pencil and eraser
- colored pencils
- markers
- black fine point pens
- palette paper

1 Apply the first layer of paint using the brayer; here I used Lemonade. When selecting colors, work light to dark.

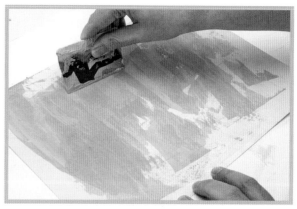

2 Squeeze a couple of acrylic colors onto a piece of palette paper and dip an old gift card into the paint. Here I used Tangerine and Citrus Green. Drag the gift card along the surface.

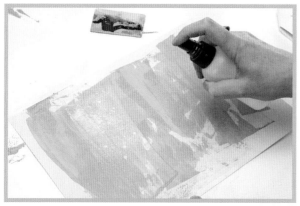

3 Lightly spray the paint with water to lift some of the colors. The water spray adds some interesting texture to the surface.

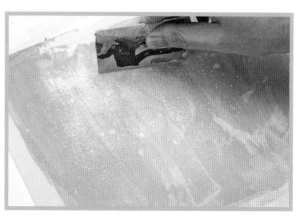

4 Continue scraping the colors to create interesting results. Notice how little dots appear when you scrape the wet paint after you sprayed it in step 3.

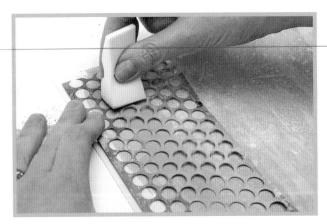 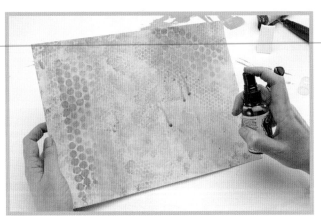

5 Use a makeup sponge to pounce Turquoise paint through a stencil. When loading the makeup sponge with paint, be sure to tap it onto the palette paper or paper towel to prevent overinking the sponge. Lightly tap onto the stencil. Try blending colors right onto the page with the makeup sponge.

6 Continue adding stencil marks. Go over lightly in one color, and while still wet apply a second color that will blend well together. Avoid complementary colors that will turn your page muddy if overmixed.

Spray the paper with alcohol inks to add color and texture. Here I used Dylusions ink sprays in Lemon Zest and Fresh Lime. Gently lift any excess ink using a makeup sponge or paper towel.

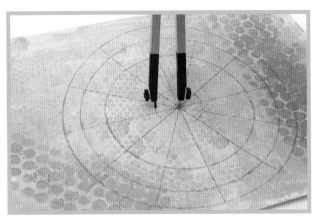 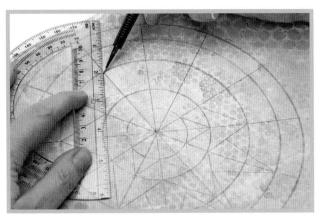

7 When the painted paper has dried completely, draw a mandala using the grid method. My mandala is about 8" (20cm) in diameter split into twelve sections (360°/12 = 0°, 30°, 60°, 90°, 120°, 150°, 180°, etc.).

8 Use a straightedge like a ruler or protractor to draw geometric shapes. If you want a more natural, flowing look, consider hand-drawing organic shapes. Refer to pages 22 and 23 to get ideas on different geometric and organic and geometric shapes that you can use to create your own mandala designs.

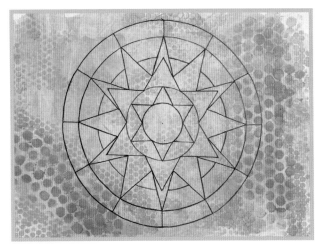 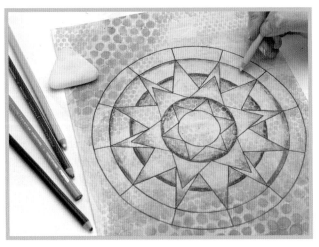

9 Ink over your mandala design with a black fine tip pen and erase any leftover pencil lines.

10 Add color to your mandala with the coloring medium of your choice. Here I used Prismacolor colored pencils.

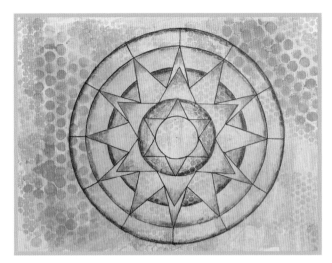

11 Erase some of the colored pencil marks with an eraser to show through some of the previous layers for a textured, distressed look.

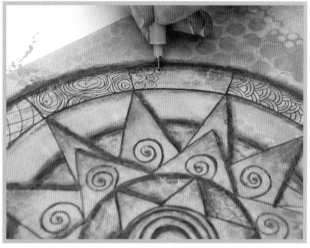

12 Use fine tip pens to add embellishments and details to the outer row of the mandala.

A Collection of My Painted Papers
Make a collection of painted papers on lots of different types of paper: mixed-media, bristol board, watercolor and photocopies of quotes and maps. Make color photocopies of your favorite painted papers to use a backgrounds for mandalas or as pieces in your collage art.

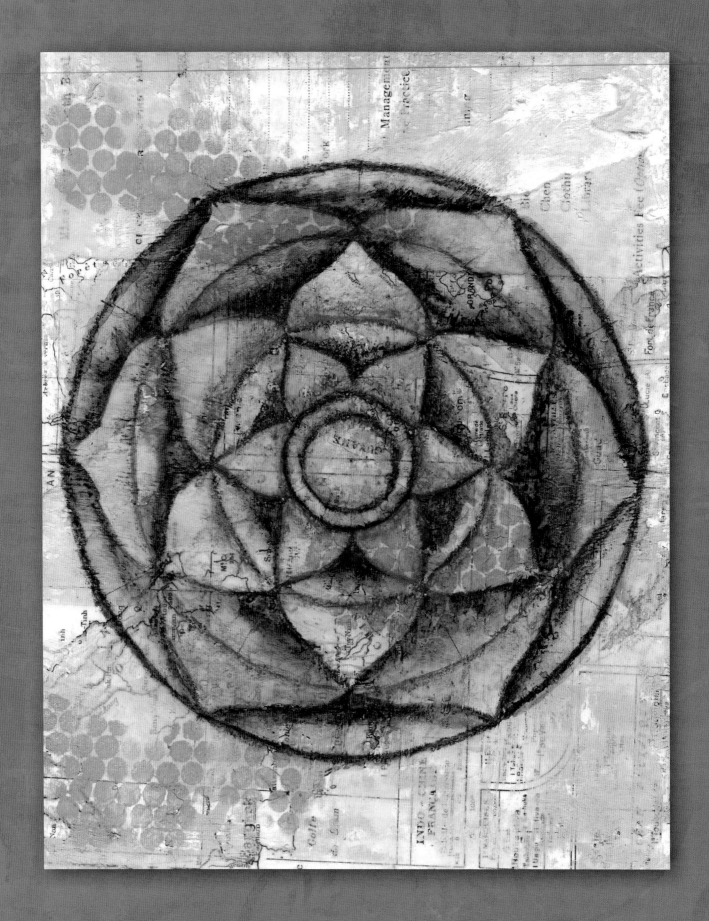

9 | COLLAGE MANDALAS

"I'M BORED," SAID ONE OF MY FRIENDS who was feeling frustrated with her mandala practice. She had taken on the challenge to draw 100 mandalas in 100 days and was beginning to lose inspiration. Drawing the same shapes and reaching for the same colors, her mandalas were all beginning to look very similar.

There are so many art forms and techniques that we can explore within the boundary of the circle. In this chapter, I share one of my very favorite mediums: collage. Collage offers a spontaneity and unpredictability to our mandalas. In the first project, torn pieces of paper, sheet music, maps, decorative papers and old book pages are layered to form an interesting background for a mandala. It is fun to see words and phrases emerge in and around the mandala. The variations in color, shape and design from the papers add interest to the final design. In the second project we cut and arrange the painted papers that we created in chapter 8 to form a unique, color-ful mandala. The results are stunning, unique and easy to create. We end this chapter by pulling out magazines to create two different collage-style mandalas. Are you ready to mix things up a bit? Let's get started.

> "It is only when we silent the blaring sounds of our daily existence that we can finally hear the whispers of truth that life reveals to us." —K.T. Jong

◀ **Tranquility** | Kathryn Costa
Colored pencil mandala on photocopied papers painted with acrylic

create a collage background

THIS CHAPTER COMBINES MY TWO LOVES: collage and mandalas. In fact, my nickname for many years has been the Collage Diva. I really like the idea of repurposing or giving new life to something that would otherwise be thrown away. Before you toss your junk mail, see if there are any hidden gems in it. Catalogs, outdated calendars, food wrappers and packaging are all potential fodder for these mandala projects.

MATERIALS LIST

- paper or canvas
- assorted decorative papers
- soft gel (matte) medium
- old flat paintbrush
- acrylic paints or inks
- compass
- protractor
- ruler
- pencil and eraser
- black fine point pen
- coloring mediums
- white gel pen
- charcoal pencil
- ink pads

1 Tear up enough pieces of printed papers to cover the background of your paper or canvas. In this example I used a variety of scrapbook papers and sheet music on top of watercolor paper.

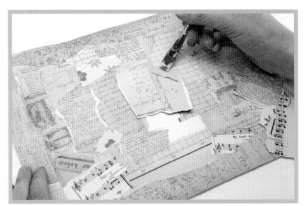

2 Brush the back of each piece with soft gel (matte) medium using an old flat brush. Coat the entire surface with more soft gel medium to varnish. Allow to dry.

3 Lightly rub Tim Holtz Distress ink pads over the surface to create an even tone among the various random pieces of paper. I like the smaller size ink pads as they give me more control over the placement of the inks. Run the darker color inks along the outside edge to give it a finished look. Allow to dry.

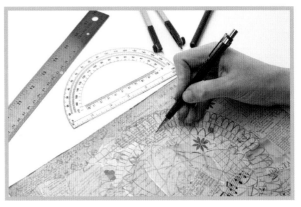

4 Use the grid method from chapter 2 to lightly draw your mandala with a pencil. In this example, I drew an 8" (20cm) circle divided into eight sections.

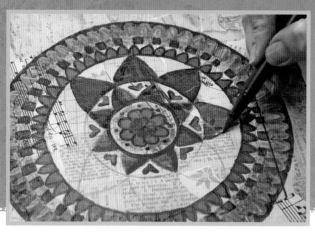

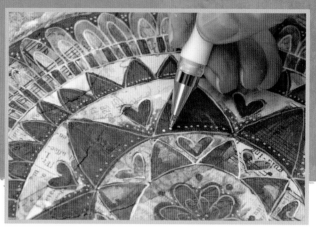

5 Decorate your mandala with a variety of coloring mediums. I used an assortment of markers. Some markers are opaque while others are transparent and designed for blending. Experiment and discover how your tools work.

6 Embellish and add details with a white gel pen.

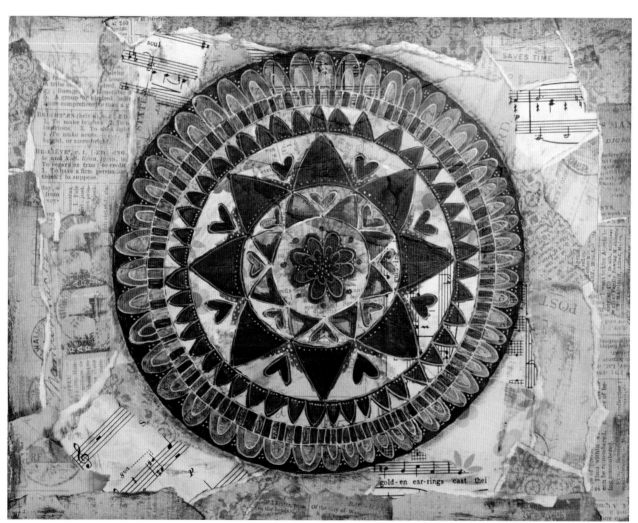

7 It is fun to see unexpected words and phrases emerge in and around the final mandala.

Make Love Your Guiding Light | Kathryn Costa
Mixed-media collage

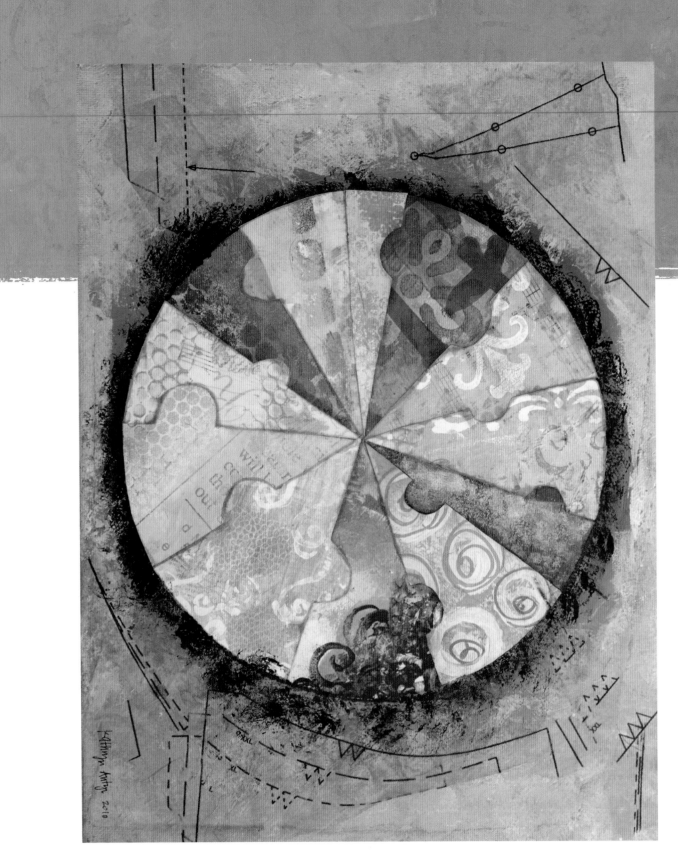

A Place for Everyone

When I originally designed this mandala for the Institute for Disability's 2011 calendar, I thought of each wedge as the people within our communities. We all come in different sizes and different shapes. The areas that protrude could be seen as our unique gifts while the indents may depict our challenges. Wholeness and unity are found within our communities when we make a place for everyone.

Unity | Kathryn Costa
Painted papers, acrylic paint and
sewing-pattern tissue paper

PIECE TOGETHER A COLLAGE MANDALA

DO YOU LIKE PUZZLES? This mandala is basically a puzzle where you create the interlocking pieces. What makes it easier than any puzzle is that you know the pattern and where each piece goes. Follow the instructions here and copy my design or use this idea of drawing a template to design your own mandala patterns. Let's cut up the painted papers that we made in chapter 8 to make a collage mandala.

MATERIALS LIST

- paper canvas
- scissors
- pencil
- painted papers
- makeup sponge
- acrylic paints
- paintbrush
- soft gel (matte) medium
- sewing-pattern tissue paper
- compass
- gesso
- old gift cards, stencils, etc.

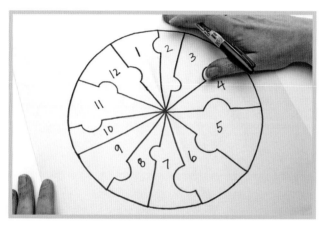

1 Decide on a layout. For this design, I drew a circle on a piece of paper using a compass and divided it into several sections with interlocking edges. Number the sections starting at the top in a clockwise direction.

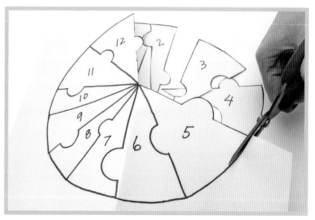

2 Cut out the pieces to use as templates.

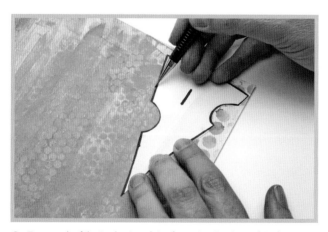

3 Trace each of the twelve templates from step 2 onto a painted paper and cut the pieces.

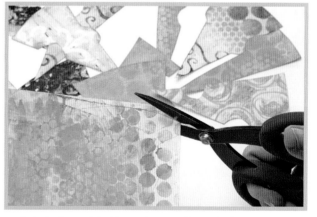

4 Refer to chapter 7 for ideas on how to achieve color harmony in your mandalas.

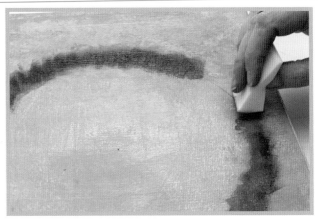

5 Prep your canvas with gesso to prevent it from absorbing too much paint. Paint the canvas using the same painting techniques we used for painting the papers in chapter 8. Select colors that will coordinate with the painted papers you selected for the mandala.

6 After the background paint has dried, draw a circle the size of your mandala and apply a layer of dark acrylic paint with a makeup sponge. This colored ring will provide a contrast between the mandala and the background.

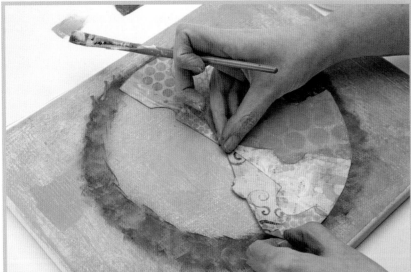

7 Using an old flat paintbrush, brush soft gel (matte) medium onto the backs of each piece and place them on the canvas. After all of the pieces are in place, brush a layer of gel medium over the top of the mandala and let dry.

8 As a finishing touch, tear pieces from a clothing pattern. Look for interesting lines, shapes and arrows. Brush gel medium on all the pieces and position them around the mandala. Apply a top coat of medium to the entire surface and let dry. See my finished piece on page 86.

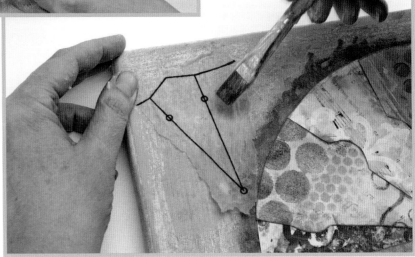

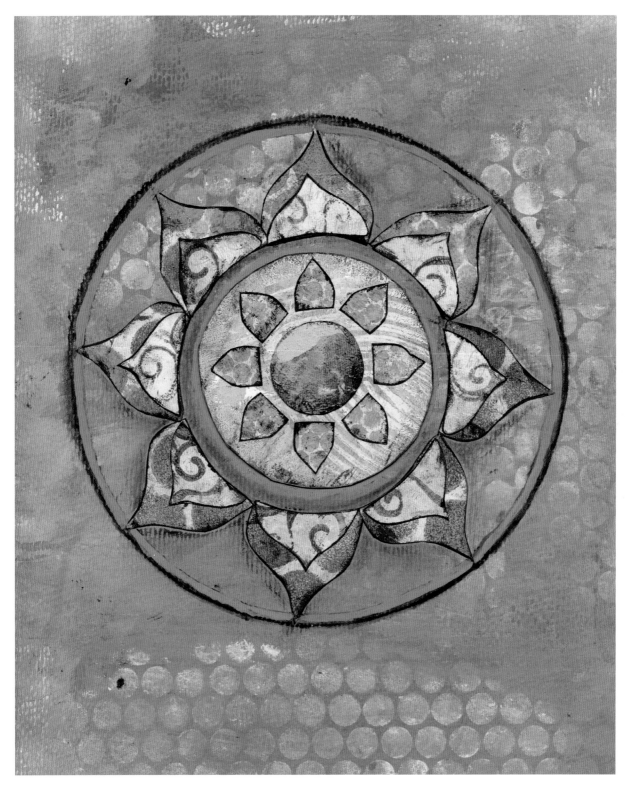

Flower Collage Mandala

Here is an example that uses the same technique of making a template and then cutting out pieces from painted papers to create a collage mandala. This layout is a familiar flower motif used in mandala design. Complementary colors—colors opposite each other on the color wheel—create an energizing and dynamic effect.

Sunshine | Kathryn Costa
Collage and acrylic on watercolor paper

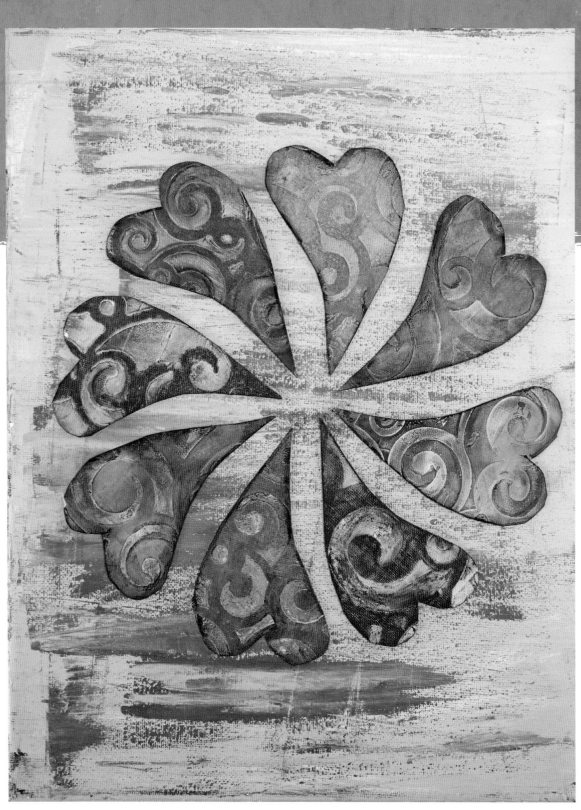

Tactile Mandala Pieces

"Ooooh, can I touch it?" Every time I show this mandala, I get this question. The juicy colors and raised texture make this a fun mandala not only to look at but to touch. This mandala is a variation of the collage mandala project on page 86 only this time the pieces have a different shape (heart) and an added textural dimension made by using wood icing.

Mandala Sisters Sharing Circle | Kathryn Costa
Acrylic paint, wood icing and charcoal on canvas

CREATE TEXTURE WITH WOOD ICING

HERE WE TAKE THE PAINTED PAPER TO ANOTHER DIMENSION—the third dimension. The secret ingredient is wood icing, a material used in woodworking for repairing and adding details to wood furniture. In our artwork, wood icing is used to create a textured layer.

MATERIALS LIST

- wallpaper sample
- acrylic paint
- brayer
- wood icing
- stencils and stamps
- old gift card
- charcoal pencil

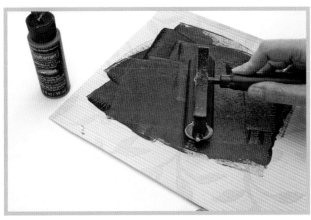

1 Start by painting your background layer. Wallpaper samples work great because the final result of layered paint and wood icing is still flexible and easy to cut. Here I rolled some dark red paint using a brayer. Watercolor paper will dry too stiff to cut into pieces.

2 Allow the painted surface to fully dry before moving on to the next step.

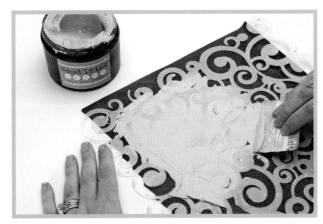

3 Lay down a stencil and scrape a layer of wood icing using an old gift card. Run the gift card over the surface several times to even out the icing. You can find Wood Icing texture paste at specialty art stores or by visiting woodicing.com.

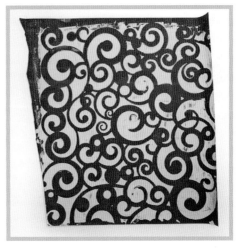

4 Lift off the stencil and allow the icing to dry thoroughly. Depending on how thick the application, this can be up to two hours.

5 Add a touch of color to the raised wood icing with an old brush and watered-down red acrylic paint. You could also use stamps or other mediums to embellish the surface.

6 Trace the stencil with a charcoal pencil. Add a variety of tones, tints and shades by painting lighter and darker colors of red or introducing a second color like orange. Run charcoal along the edges to emphasize the sense of depth and to accentuate the interesting shapes.

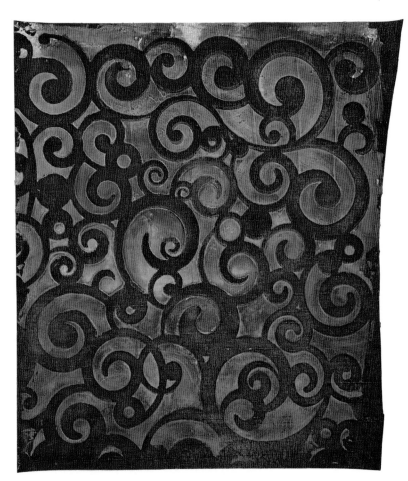

8 When you cut shapes out of the painted papers, look for the sweet spots. Here the spiral was lined up to make an interesting decorative element within the heart. Cut the wood icing papers into eight hearts in various colors for the finished mandala on page 90.

7 Once dried the wood icing painted papers are ready for your projects. Since this can be a time-consuming and messy project, I recommend creating several sheets at once and varying the colors that you paint for each one. I often have prep days in my studio when all I do is create a collection of painted papers. On other days I have fun picking from my restocked stash of custom papers to create my mandala art.

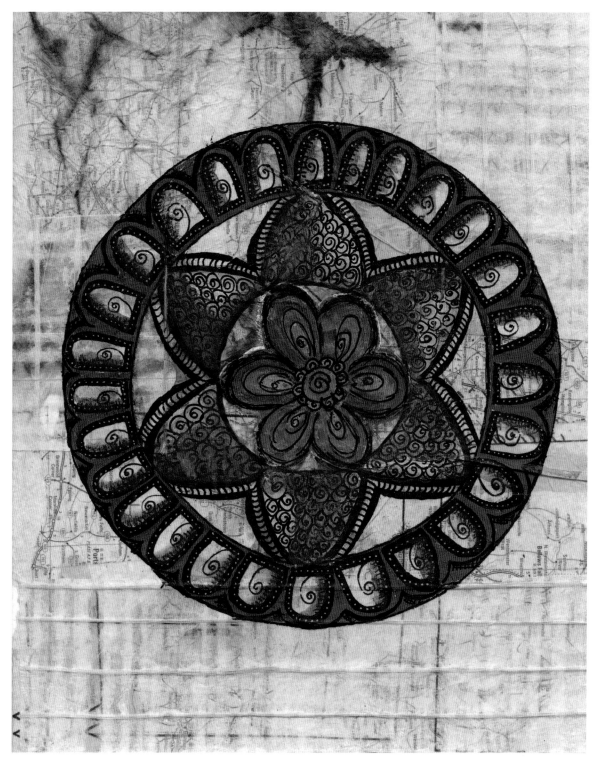

Layered with Love

In this example the background was built up in layers starting with pieces of torn up and randomly glued down old maps and sewing-pattern tissue. Handmade white paper with fine pieces of bamboo added texture and quieted the busy patterns found in the map layer. As a finishing touch, a layer of tissue paper that has been stained with coffee grounds added a distressed and interesting element to the page. Once dried, the mandala was painted over the background.

Finding Beauty | Kathryn Costa
Paint pens, acrylic paints, markers on a background of handmade paper, old maps and sewing-pattern tissue paper

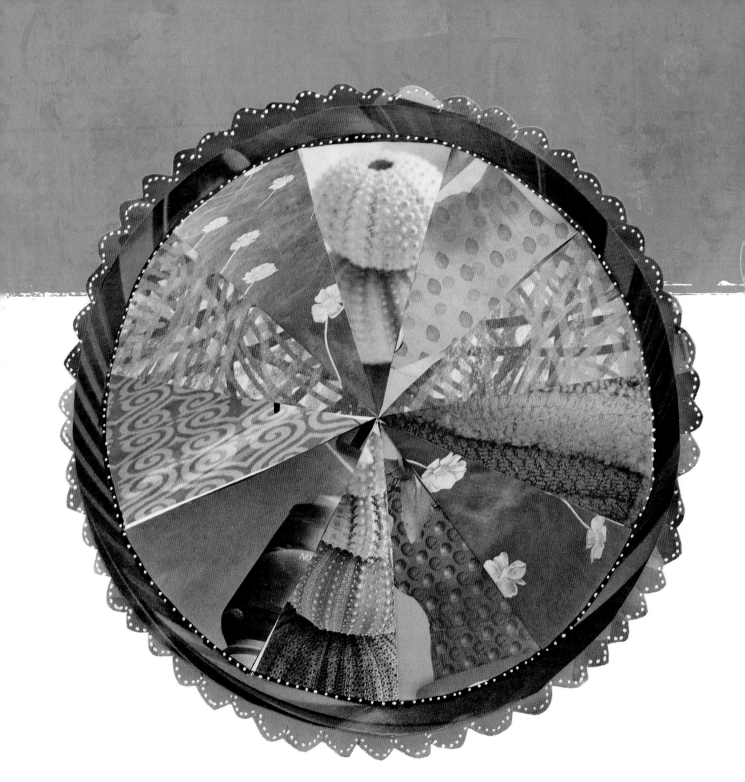

Use the "Oooh" Factor to Select Colors

Fashion and home decorating magazines are packed with gorgeous colors and patterns. As I tore through my magazines, I found myself gravitating toward purples and oranges. I didn't consciously plan the color scheme in this mandala; I stopped at anything where I said "oooh" or "aaaaah." Not every page I pull out makes it into the final design. I'm okay with that as I know those pages will likely get worked into another project.

Magazine Wheel | Kathryn Costa
Magazines, black permanent marker, white gel pen on cardstock

Magazine Mandala | Style 1

CREATING COLLAGES AND MANDALAS USING MAGAZINES is one of my favorite pastimes. The results are always unexpected; you never know what visual gems and inspiring phrases you'll find flipping through the colorful pages. The two projects in this chapter do more than repurpose your old magazines; they are an opportunity to study color, pattern and shapes without mixing paint and getting messy. So dust off that stack of glossies, get your scissors and glue stick ready and let's collage!

MATERIALS LIST

- stack of old magazines
- scissors
- glue stick
- compass
- protractor
- ruler
- pencil
- cardstock
- scrapbook paper
- sheet music
- white gel pen
- permanent black marker

1 Using a compass, draw two 6" (15cm) circles on cardstock and cut them out. One circle will be used to cut your wedge template, the other as a base. Since this will be used as a template, old file folders or greeting cards are a good source for heavy paper.

2 Fold one circle from step 1 in half and cut along the crease.

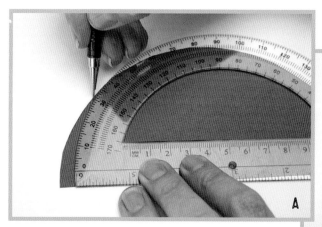

A

B

3 Use your protractor and pencil to mark at 30° along the semicircle. Use a ruler to draw a straight edge from the center of the semicircle to the 30° mark, then cut along the line to create a wedge. You can make the wedge as large or small as you like; for this demo I made them at a 30° angle.

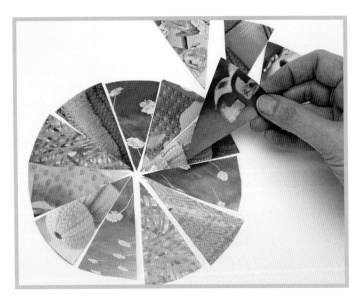

4 Tear pages from magazines to use for your pie pieces. Collect a variety of colors, patterns and textures that grab your attention. I work quickly in this stage and try not to get pulled into the articles. Don't overthink your choices. Trust your intuition.

Using the template that you created in step 2, trace and cut the wedge shapes out of the magazine pages. Be sure to cut out several wedges from each page so that the color can be repeated in the final design. Look for interesting patterns, words and images.

5 Arrange the magazine wedges into a circle. Think in terms of contrast and balance as you decide the placement of the different colors.

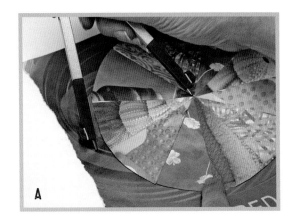

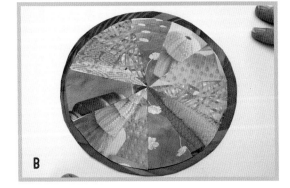

6 Create a border/background for your mandala pie pieces to be glued to. Select a magazine page in a color that either contrasts or coordinates with the colors in your wedges. Use a compass to draw and cut out a 6½" (16½cm) circle. Use a glue stick to glue the wedges to the background circle. Line up each point in the center.

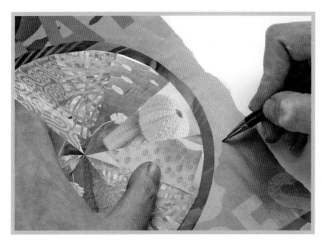

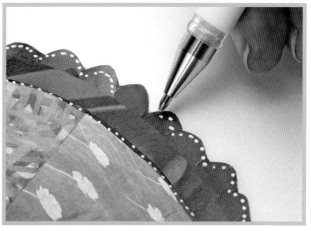

7 Select another magazine page in a coordinating color to create a scalloped-edge border. Draw a 7" (18cm) circle. Draw a scalloped edge along the outside border of the circle and cut out with scissors. Glue the mandala and base from step 6 to the scalloped circle.

8 For a finishing touch outline the inner mandala with a permanent black marker and dot the edges of the two border circles with a white gel pen. Fun idea: Glue the finished mandala to a journal page or frame it!

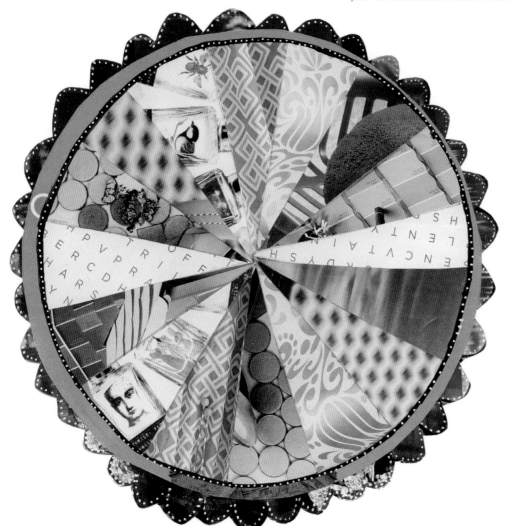

Hidden Messages

It wasn't until after I looked at this finished mandala that I saw the word *PRAY* in red letters in the wedge on the far left side. Take time with your mandalas; you may just find little unexpected messages within them.

Prayer Wheel | Kathryn Costa
Magazines, black permanent marker and white gel pen on cardstock

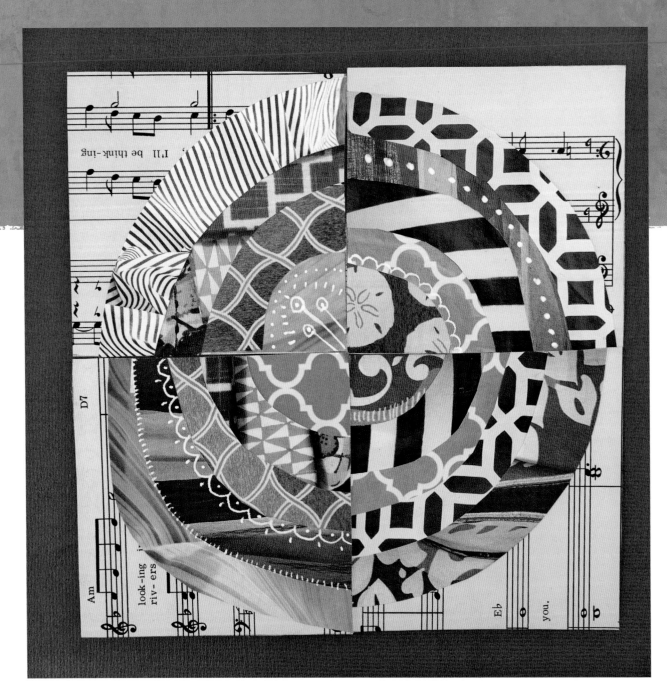

Meaningful Colors

After you've made your magazine mandalas, take some time to look at them. Do the colors remind you of anything? Spend some time in your journal listing all the colors and your associations with them. Some might invoke a memory. After you've thought about these colors, turn to page 107 and consider the common meanings for the colors. What connections can you make?

Thinking of You | Kathryn Costa
Magazines, sheet music and white gel pen on cardstock

magazine mandala | style 2

AS WITH THE PREVIOUS MAGAZINE MANDALA, begin by tearing pages from magazines. Collect a variety of colors, patterns and textures. Think about the color palette as you pull pages. Some days I am drawn to vibrant colors, on others more moody tones. Pick the colors that you are drawn to in the moment and allow your intuition to guide you as you make your selections. Most of all, don't overthink it and have fun! Jane LaFazio's playful and whimsical fabric circles were the inspiration for this magazine mandala. Be sure to check out her fabric circles in the gallery section on page 136.

MATERIALS LIST

stack of old magazines

scissors

glue stick

journal or background paper

compass

ruler

pencil

cardstock

scrapbook paper or sheet music

white gel pen

craft knife

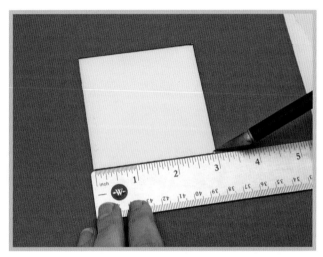

1 Create a viewfinder. Using a piece of cardstock or old file folder, cut out a 3" × 3" (8cm × 8cm) square using a craft knife.

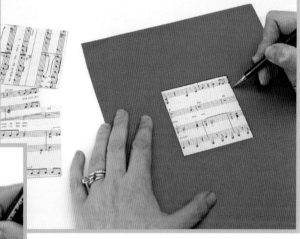

2 Select a neutral background paper. I like using sheet music or scrapbook paper. Using the viewfinder as a template, trace out four 3" × 3" (8cm × 8cm) squares. Cut out each square.

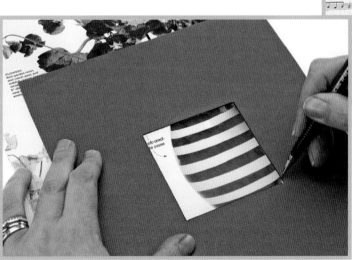

3 Use the viewfinder to find the sweet spots in your magazine pages. Trace and cut out squares, collecting a dozen or more in a variety of colors.

4 From one of the colored squares, cut out an arc that starts at the top and extends to the bottom. You might have a knack for cutting a curved line, but the first time I tried this exercise my arcs were not circular and the final mandala was more square shaped than circular. I rely on my compass to help me with the first cut. To use a compass to create an arc, place the needle directly on one of the corners and trace from one end of the square to the other.

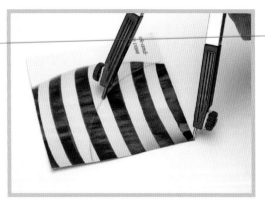

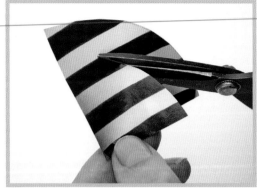

5 After you have your first cut, follow that curve to ballpark a second cut. This is the first segment.

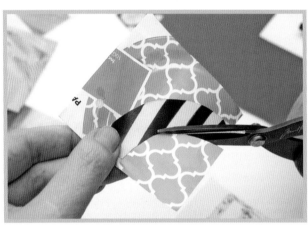

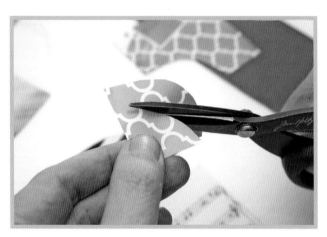

6 Select a second colored square and using the inside edge of the first segment from step 4, create the first cut on the next piece.

7 When you make the second cut, vary the width. I don't like to measure the second cuts for the segments. By working freehand, the result will be playful and whimsical.

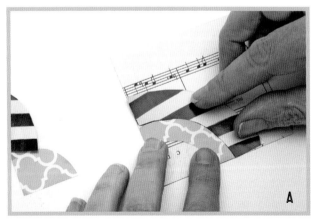

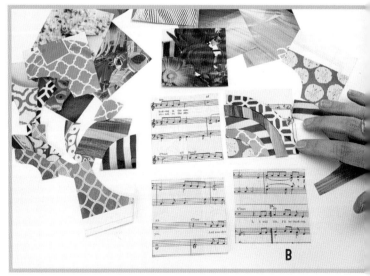

8 Continue to cut segments until you have enough to fill a background square. Arrange the colorful segments and glue them to each square in a pleasing pattern. The segments may overlap and you may find that leftover pieces from cutting the different segments fit in perfectly. Repeat steps 4 through 8 until you have four completed squares.

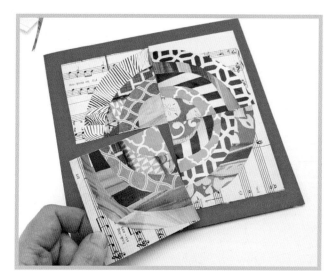

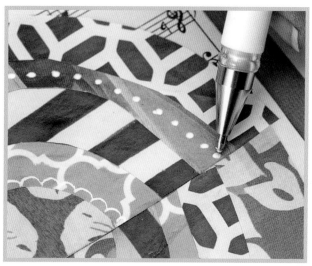

9 Arrange the four squares to complete the circle. Glue the squares down onto a piece of 7" × 7" (18cm × 18cm) scrapbook paper.

10 Add finishing details and embellishments by adding dotted or dashed lines with a white gel pen. When you work with a gel pen on the glossy magazine pages, be careful not to smudge the surface. Give the gel time to dry before handling the mandala.

Finding a Title

Look at all of the magazine mandalas in this chapter and see if you can find the inspiration that led to the title.

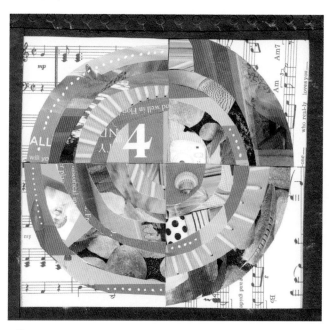

All For You | Kathryn Costa
Magazines and white gel pen on sheet music

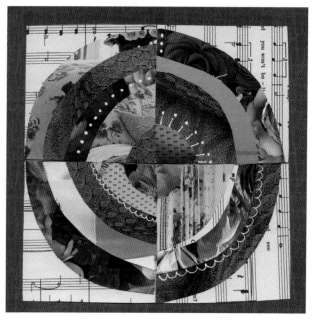

You Won't Believe It | Kathryn Costa
Magazines and white gel pen on sheet music

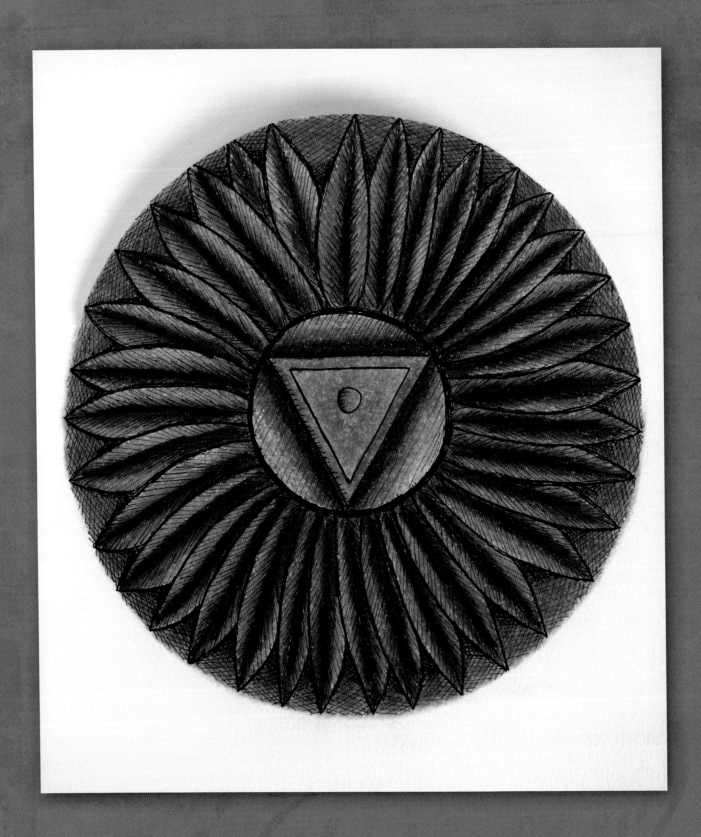

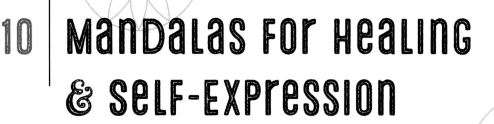

10 | MANDALAS FOR HEALING & SELF-EXPRESSION

SWISS PSYCHIATRIST CARL G. JUNG introduced to the West the practice of creating mandalas for self-expression, discovery and healing. In Jung's daily practice of creating mandalas, he discovered that the shapes, colors and symbols reflected his mental, emotional and spiritual well-being at the time that he created them. Reflecting on these mandala drawings, Jung concluded that our subconscious and conscious selves are always seeking balance, whether reconciling an old hurt or overcoming a challenging situation. Through years of study and observation, Jung also identified universal patterns and archetypes that occurred in his and his clients' mandalas. A great resource filled with exercises to explore this approach to mandala making is *The Mandala Workbook: A Creative Guide for Self-Exploration, Balance and Well-Being* by Susanne F. Fincher.

On the same note, through the mandala-making groups that I facilitate, I've observed how the practice of creating mandalas helps participants to work through challenging situations in their lives, such as:

experiencing the loss of loved ones and the grieving process
coping with depression and anxiety
receiving a scary diagnosis or living with a chronic illness
working through difficult relationships
navigating life transitions
contemplating big decisions

When creating mandalas for personal enjoyment and reflection, there are no rules. One can draw symmetrical patterns or fill the circle with shapes and colors in any way. It is entirely up to the person drawing the mandala.

"Not all those who wander are lost." —J.R.R. Tolkien

◀ **Mandala Shield** | Kathryn Costa
Colored pencil on journal page

BENEFITS OF MANDALAS

HERE ARE JUST A FEW of the many amazing benefits of drawing mandalas:

- Relaxes the body and mind
- Cultivates the feeling of happiness, inner peace and general well-being
- Eases stress, anxiety, worry, overwork, fear and depression
- Activates creativity and improves focus
- Enhances self-esteem and self-acceptance
- Fosters a sense of connectedness with oneself and others
- Improves sleep
- It's fun!

SPREAD YOUR LOVE OF MANDALAS!

It was love at first sight for Fabienne Tosi, who started drawing mandalas the summer of 2014.

"I couldn't stop," said Tosi. "I saw mandalas everywhere and was thinking about mandalas all the time. I live in Geneva, Switzerland, and my mother lives in the South of France. A couple of months after I discovered mandalas, I was telling my mother about it. I emailed a few of my drawings to show her what I was so passionate about. She was so curious to learn how I drew them. I gave her a few instructions and within two weeks, I was surprised to find in my mailbox two mandalas that she had created."

Her mother started with drawing mandalas, then moved on to embroidering cushions and napkins and the painted porcelain plates. This is a bittersweet story as Fabienne's mother recently passed away after complications from a stroke. Her last spoken words to Fabienne were, "I can hear you and mandalas."

HOW TO INTERPRET YOUR MANDALAS

SOMETIMES THE BEST WAY TO UNCOVER THE STORY
is to pull out your journal and free-write what you see and feel looking at the mandala. Set a timer for five to fifteen minutes and don't stop writing. Another approach is to write in your journal using your nondominant hand. Although it may feel awkward to write with the hand you usually don't use, it is a great way to tap into your intuition.

Egg Yolk In Motion | Kathryn Costa
Oil pastels on black paper

EXCERPT FROM MY JOURNAL

July 10, 2010

Today I approached my mandala-making differently. I started from the outside and worked my way inward. I usually start from the center and work outward. Typically I draw the shapes first and then color them. This time I started by working with colored markers to create different shapes arranged in a circle and then went in with a fine-liner pen to outline and add details. I see the rocks in this mandala as stepping-stones and a wall that offers protection. The lonely heart in the middle is caught in the waves. The water swirls around catching in between the rocks. The perimeter is solid—it is holding everything neatly. What would it look like if the perimeter was broken? I like to collect heart-shaped rocks and this rock looks like it is waiting to be found. These days I often feel like a lonely heart waiting to be found.

Loosen Up By Journaling

Both of the mandalas on this page are examples of when I worked intuitively and didn't plan the layout or work within a grid. I worked with my feelings rather than by thinking. To help me to loosen up and play intuitively, I like to use pastels or paints to swirl colors within the mandala. To the left is an excerpt from my journal that accompanied my *Waiting to Be Found* mandala. It was completed during the time in my life when I was a single mother.

Waiting to Be Found | Kathryn Costa
Markers in journal

COLOR INTERPRETATION

WHILE IT IS TEMPTING TO USE THE COLOR CHART on the facing page to look up the meaning of a color in your mandala, it is important to remember that your mandala is a reflection of you and your subconscious mind. You may look at the color red and associate it with romantic love, or it may remind me of the many nosebleeds I would get as a child. Since how we perceive color is so personal, it is important to look within and consider our own associations and feelings before referring to the common meaning.

When you do refer to the color chart, reflect on the different interpretations connected with the colors and how you respond to them. Each color has both positive and negative associations. Some of the words will tie in with your mandala story and feel right, while others won't fit. Listen to your intuition to hear the story of your mandala. A good way to listen to your intuition is to notice how your body reacts as you read through the words. Do you feel energized or does your body tighten up? Notice when you feel resistance compared to the feeling of expansiveness. All of these feelings will guide you in understanding your mandala story.

MANDALA COLOR EXERCISE

Try this exercise to gain a better understanding of how to interpret the colors in your artwork. First, list the colors that you used in your mandala. Start by writing down any associations that you have for each color. What do you see, feel and think as you look at your mandala?

Now refer to the color chart on the facing page. Look up the colors and write in your journal the words from the chart that speak to you. Spend some time writing in your journal about your observations.

DISCOVERING THE STORY OF YOUR MANDALA

It isn't always easy to give your mandala art a title. This exercise will help you to take a closer look at your mandala and begin to see the story that it tells. I like to think of this exercise as an invitation to have a conversation with my mandalas.

1. Make some time to sit with your mandala.
2. Observe the shapes and symbols. Do the shapes hold any meaning for you?
3. What were your thoughts and feelings when you were creating this mandala?
4. What colors did you use?
5. What feelings do you have looking at your mandala?
6. When you look at your mandala, consider everything in the circle as representing your internal world of thoughts and ideas, and everything outside of the mandala as the people, places and events around you. You can also think of the center of the mandala as you and the shapes around that center as your external world.
7. Write your thoughts and observations in your journal.

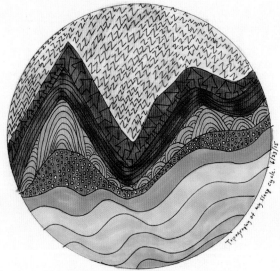

What Story Does Color Tell?

As I drew this mandala, I thought about my sleep cycles. Compare the energy of the bright pinks and oranges in this mandala with the blues and greens. The warm colors are representative of my fluctuating hormones while the cool colors illustrate how underneath the stress there is a calmness.

Topography of My Sleep Cycle | Kathryn Costa
Markers on journal page

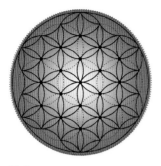

Pink

(+) friendship, compassion, generosity, warm-heartedness, gratitude, affection

(-) weak, immaturity, childish

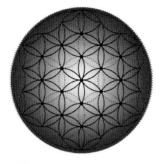

Red

(+) love, passion, excitement, determination, courage

(-) anger, rage, frustration, resentment, anxiety, depression, warning

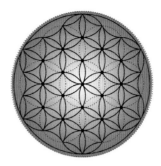

Orange

(+) creativity, enthusiasm, joy, optimism, persistence, success, imagination

(-) poor boundaries, mood swings, emotional dependency, not connected to one's core self

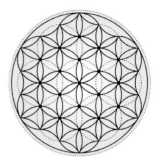

Yellow

(+) warmth, happiness, energy, cheerfulness, confidence, healthy self-esteem

(-) blaming others, sarcasm, cynicism, shame, low self-esteem

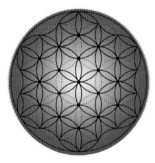

Violet

(+) wisdom, dignity, insight, clarity, integration, intuition, imaginative

(-) sadness of letting go, deep grief, stuck in one truth, frustration, delusions, arrogance

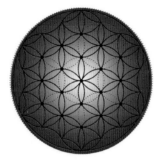

Blue

(+) tranquility, calm, soothing, healing, faith, heaven, trust, listening to your intuition and to others

(-) cold, depressing, poor communicator, interrupts others, anxious, gossipy

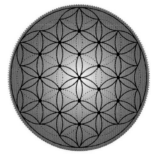

Green

(+) unconditional love, compassion, growth, life, balance, calm, soothing, stability, endurance

(-) perfectionist, sees only with reason and intellect, overly sacrificing

Brown

(+) genuine, wholesome, honesty, steadfastness, simplicity, friendliness, dependability

(-) sadness, wistful

Gold

(+) warm, illumination, wisdom, courage, accomplishment, wealth

(-) somber, excess, deceit, cheat

Silver

(+) intuition, hope, tenderness, kindness, mirror of the soul, helping to see ourselves as others see us

(-) liar, insincere, indecisive, dull, noncommittal

White

(+) goodness, purity, innocence, perfection, safety, faith, gentleness, cleanliness, a successful beginning

(-) isolation, emptiness

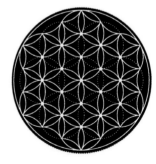

Black

(+) strength, authority, protection, power, elegance, formality

(-) fear, unknown, grief, submission, death, mystery

gratitude

IT IS EASY TO COUNT OUR BLESSINGS when everything is sunny and cheery, when the kids are behaving, and the bank account is flush. We need our gratitude practice the most during challenging times. In this exercise, think about an area in your life where you are struggling. Maybe you are having a difficult time at work or with a specific person. As you work on this mandala design, think of eight things you are grateful for about this situation or person. When you are done, I guarantee you'll feel a greater appreciation for the person or situation, and you'll have had fun making this mandala.

MATERIALS LIST

- bristol board
- compass
- pencil and eraser
- black fine point pens
- fine-point permanent markers
- protractor
- ruler

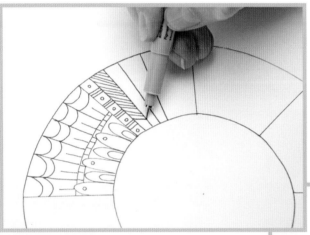

1 On bristol board, draw your mandala in pencil using a compass. Divide the outer circle into eight segments using a protractor and ruler. Outline the mandala with a black fine point pen. Draw repeating shapes in the eight containers. Be sure to leave spaces for writing words and short phrases.

2 Color in the shapes using bright juicy colors. Color has a way of lifting up our moods. I used extra-fine point Sharpies to get great detail.

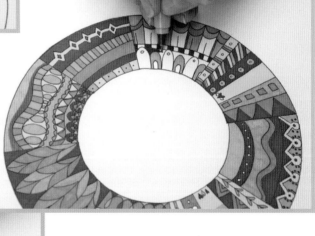

3 Think about a challenging situation you are experiencing in your life and record one thing you appreciate or feel gratitude about in each of the eight sections that you just colored. It helps to journal these words after applying color so the words will not bleed.

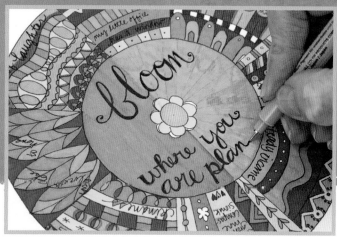

4 At the center of your mandala draw a flower. Color the background with green and blue Sharpies or other permanent markers. Note that in the green section, I created balanced radial lines by drawing in small triangular sections. In the blue section I colored straight up and down for a nice vertical pattern.

5 Finish by adding the title "Bloom Where You Are Planted" in the center using a fine point marker.

Visual Reminders

I have this mandala hanging up next to my desk. Any time I'm feeling stressed, overworked or frustrated, I look at the colorful patterns and read the little messages. It really helps me to turn my mood around, and it reminds me of all the good things surrounding me.

Bloom Where You Are Planted | Kathryn Costa
Markers on bristol board

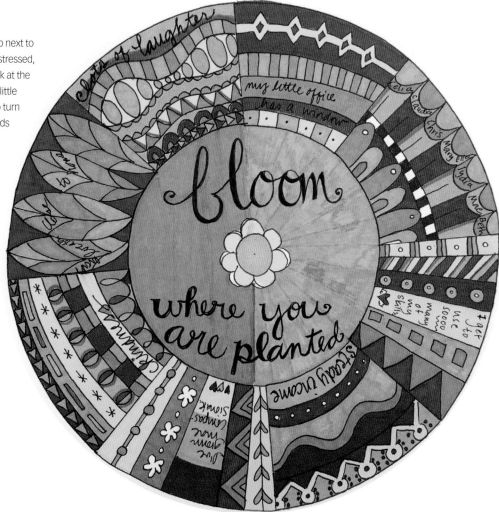

MANDALA PROMPTS FOR GRATITUDE

My gratitude practice started years ago when I was a single mother. At the end of the day at bedtime, my son and I would race to my bedroom and jump on the bed. The first person to get there would blurt out, "Name three things that made you happy in the day." We would then take turns naming the highlights of our day. At first it was a little challenging and it felt awkward. Like most things, with practice it came easier. Knowing that we would be reporting in, we found ourselves looking for happy moments as we moved through our days. Over time we started noticing the types of things that made us happy: connecting with people, learning new things, our accomplishments, and of course, exercising our creativity. We also noticed how our appreciation for what we had expanded beyond the big things in life and included the smallest, most subtle aspects of living, like the cool breeze on a hot day, the feel of soft grass between our toes, and a new flower bud beginning to open. I witnessed a change in both of us when we adopted an attitude of gratitude: We grew in thankfulness, appreciation, compassion, generosity, humility, grace, trust and joy. These mandala prompts are designed to encourage you to weave gratitude into your mandala practice and make it part of your daily life.

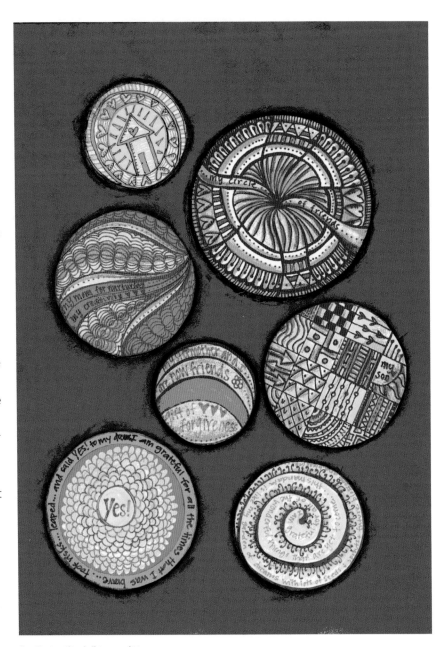

"Daily Gratitude" Journal Page
Draw seven circles on your journal page. Vary the sizes of the circles. Each day fill in one of the circles with patterns (see chapter 4) and colors. Record something that you have been grateful for during the day. Once you have all seven circles filled, cut them out and paste them onto a piece of painted paper (see chapter 8). Outline the circles with charcoal.

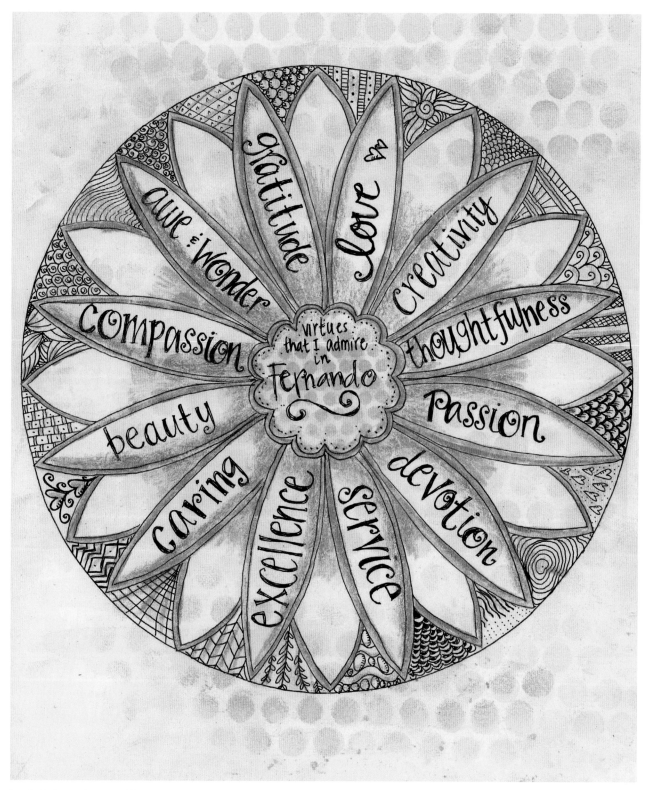

"I Admire" Practice Mandala

Create a mandala of a flower with broad leaves. In the center write the name of the person whom you admire. In each of the petals write down a virtue or trait you admire about the person. Which of the qualities do you share with this person? Which ones do you want to cultivate in yourself? This mandala was created using the grid method (chapter 2) drawn onto a piece of painted paper (chapter 8) and embellished using patterns and fillers (chapter 4).

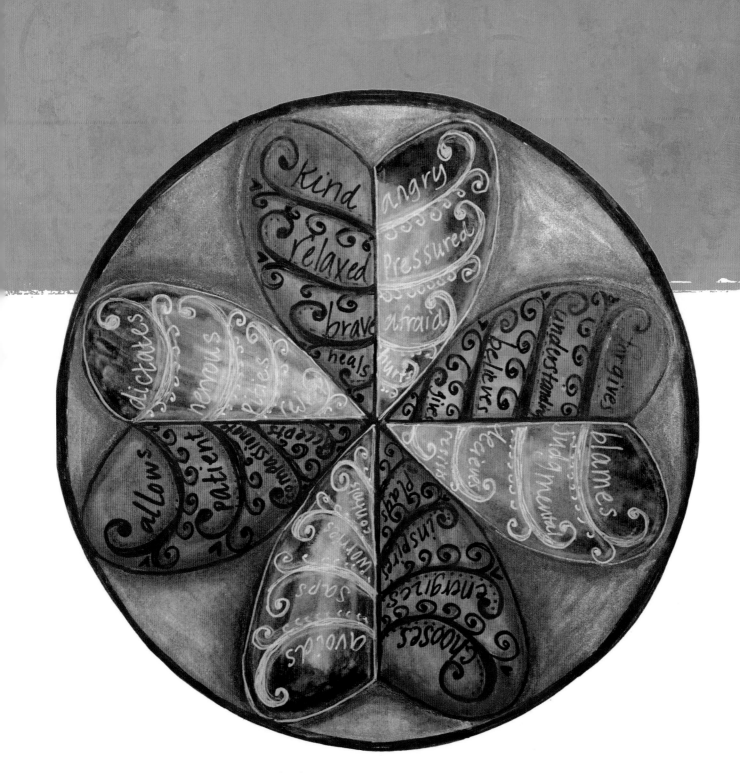

Do You Feel Lucky?

"The Luck Factor" is a ten-year scientific study by Richard Wiseman that found that "lucky people generate their own good fortune via four basic principles. They are skilled at creating and noticing chance opportunities, make lucky decisions by listening to their intuition, create self-fulfilling prophesies via positive expectations, and adopt a resilient attitude that transforms bad luck into good." I bet lucky people are also likely to have qualities found on the love side of the love-fear flower mandala.

Love .v. Fear Mandala | Kathryn Costa
Watercolor pens and markers on bristol board

Love vs. Fear

CREATING ART GIVES US A WAY TO SLOW DOWN. While focusing on drawing the lines and coloring within the shapes of our mandalas, we begin to let go of the busyness of our daily lives. Our bodies relax and our minds take us on a journey. It is a good time to tune in and ask yourself, *How am I feeling?* Start now with this question. Pause, take a deep, cleansing breath (or two) and consider where you are in this moment.

All emotions and actions are derived from two roots: love and fear. Think about it: sadness, anger, judging, nervousness are all examples rooted in fear. In contrast, feeling cheerful, kind, understanding and patient are based in love. I'm fascinated by how words have the power to lift us up and inspire us or tear us down and hold us back. What words are you using to tell your stories? Are they empowering you or are they keeping you stuck in fear? Let's explore this love-fear connection in our mandalas.

MATERIALS LIST

- paper of your choice
- pencil and eraser
- compass
- protractor
- ruler
- black fine point pens
- watercolors and brush pen
- white gel pen
- black and white charcoal pencils
- water
- paper towel

1 Using a pencil and compass, draw a circle. Divide the circle into eight sections. Using a protractor mark your circle at 45°, 90°, 135° and 180°. Using the eight lines as guides, draw four hearts.

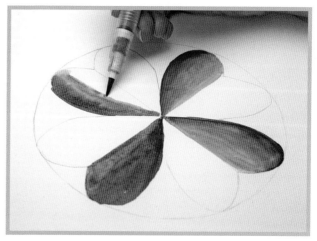

2 Erase the guidelines between the hearts and at the top of each heart, but keep the guideline down the center of the heart. Paint the left side of each heart red. Here I'm using my favorite Japanese watercolor set that comes with a refillable brush pen. I like how the pen has a chamber filled with water. This makes it easy to clean the brush in between changing colors. I also get great results with the brush tip.

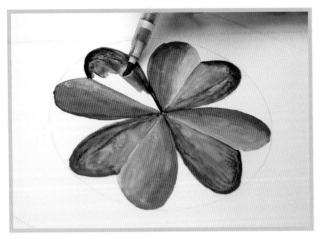

3 Paint the right side of each heart blue.

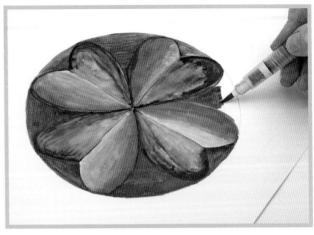

4 Paint the spaces in between the hearts with brown.

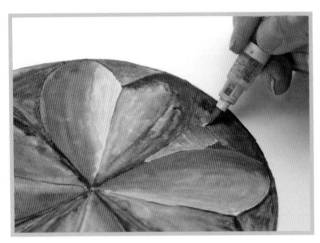

5 With a wet brush, brush gold over the brown areas.

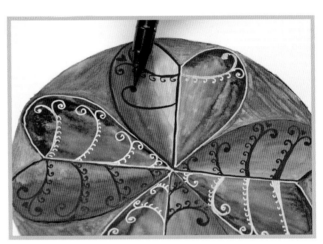

6 Allow the paint to dry really well before adding details. Use a black pen for writing on the red sections and a white gel pen for the blue sections, drawing curved lines in black and white. Space these lines to give you plenty of room for journal writing.

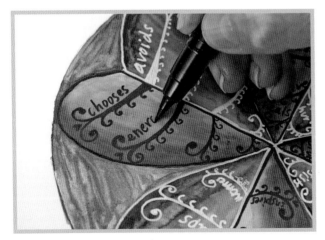

7 Refer to the list of love versus fear words on the facing page and select the ones that grab your attention. Record the love words on the red (warm) side and the fear words on the blue (cool) side of each heart.

8 Use a compass to draw an outer circle to create a border. Color the border in black.

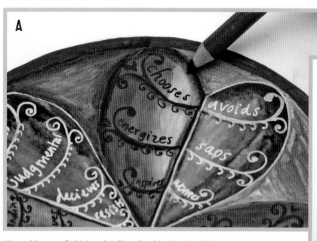

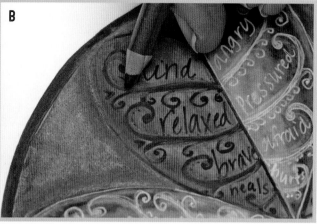

9 Add some finishing details using black and white charcoal pencils.

EXPLORING LOVE VERSUS FEAR

"Love is what we are born with. Fear is what we learn. The spiritual journey is the unlearning of fear and prejudices and the acceptance of love back in our hearts. Love is the essential reality and our purpose on earth. To be consciously aware of it, to experience love in ourselves and others, is the meaning of life. Meaning does not lie in things. Meaning lies in us." —Marianne Williamson

love is unconditional (fear is conditional)
love is strong (fear is weak)
love releases (fear obligates)
love surrenders (fear binds)
love is honest (fear is deceitful)
love trusts (fear suspects)
love allows (fear dictates)
love gives (fear resists)
love forgives (fear blames)
love is compassionate (fear pities)
love chooses (fear avoids)
love is kind (fear is angry)
love ignites (fear incites)
love embraces (fear repudiates)
love creates (fear negates)
love heals (fear hurts)
love is magic (fear is superstitious)

love energizes (fear saps)
love is an elixir (fear is a poison)
love inspires (fear worries)
love desires (fear joneses)
love is patient (fear is nervous)
love is brave (fear is afraid)
love is relaxed (fear is pressured)
love is blind (fear is judgmental)
love respects (fear disregards)
love accepts (fear rejects)
love dreams (fear schemes)
love wants to play (fear needs to control)
love enjoys (fear suffers)
love frees (fear imprisons)
love believes (fear deceives)
love "wants" (fear "needs")
love versus fear: what do you feel?

by Sarah Nean Bruce and originally published on tinybuddha.com

Organizing Your Ideas

Have you noticed how relaxing it is to color mandalas? When you are in this relaxed state, it is a good time to think about a decision that you need to make or brainstorm ideas to solve a problem. The shapes and spaces within a mandala offer containers perfect for recording ideas. In this example, the petals become a creative way for making a list.

How I Blossom | Kathryn Costa
Watercolor pencils and gold paint pen on an acrylic background

HOW TO BLOSSOM

MATERIALS LIST

paper

pencil and eraser

compass

protractor

ruler

water-soluble colored pencils

round paintbrush

water

paper towel

gold paint pen

fine point black pen

painted paper background

acrylic paint

makeup sponge

glue

stiff bristle brush

NATURE CREATES THE MOST BEAUTIFUL MANDALAS. Radiating from the center are rows and rows of petals. While each flower is perfect, look closer and you'll notice some imperfections. As close as it may be, not every petal is exactly the same size and shape. The flower motif emerges often in our mandalas, and it is very easy to draw. As you work on your flower mandala, think about what you need to blossom. Just as flowers need water and sun, our bodies and spirit need nourishment. Ask yourself these questions:

What does my body need right now?

What is my heart longing for?

Which relationships need my attention?

Where do I need to place my energy?

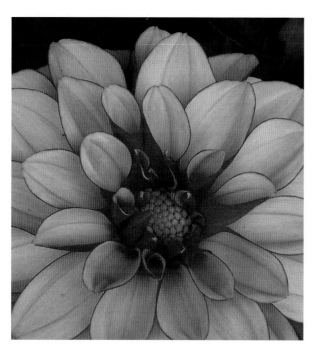

1 Look to nature for inspiration. Notice how the petals are not perfect. Point this out to your inner perfectionist the next time she is commenting on the imperfections in your mandala art.

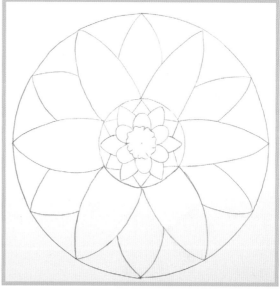

2 Create a grid mandala by dividing a circle into twelve sections (see chapter 2) on the paper of your choice, such as bristol board, watercolor paper or mixed-media paper. Draw flower petals large enough for journal writing. To make the design more interesting, I overlapped the petals.

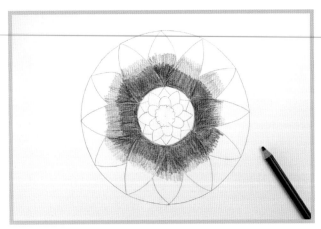

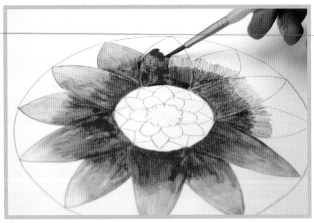

3 Add color using Inktense or watercolor pencils. Here I used a Fuchsia Derwent Inktense pencil. Begin by coloring the large flower petal shapes. Apply color only to the base of the petal, leaving the tip uncolored.

4 Lightly wet a small round brush with water. Brush the water inward to the outer edge of the petals for a nice dark-to-light gradient. See how the colored pencil pigment marks change into a blended watercolor effect.

5 Color the spaces between the petals and outer ring with Bright Blue and Field Green Derwent Inkense pencils. Use a clean brush and water to softly blend the blue and green areas. If bleeding occurs, use a paper towel to gently clean up the edges.

6 Color the center of the flower with Fuchsia and Tangerine Derwent Inktense pencils. The gold petals were painted using a gold acrylic paint pen.

7 Add fine details to the center of the flower and petals with a black fine point pen.

DERWENT INKTENSE PENCILS VS. WATERCOLOR PENCILS

Inktense pencils are made of ink and dry in vibrant colors while watercolor pencils dry lighter than when they are wet. When dry, Inktense colors are permanent, while watercolor can be reworked by adding water after it has dried. Both give beautiful results. Selecting them is really a matter of personal preference. When sharpening your pencils, always use a circular motion. If you sharpen in a twisting back-and-forth motion, the pencil tip can splinter and break.

8 Use black fine point pens or markers to journal in each petal. Write down words that will help you to "blossom" and be your best self. My words include *friends*, *curiosity*, *creativity*, *meditation* and, of course, *drawing* and *coloring mandalas*.

9 Finish the mandala by adding a ¼" (6mm) gold border using the gold paint pen and fun dot details in the blue-green spaces and central pink flower. Cut out the mandala.

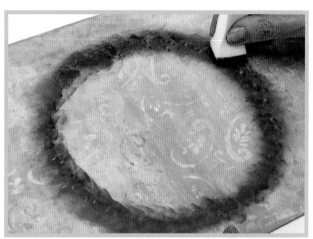

10 Create a painted paper for the background following the demonstration in chapter 8. Here I used cheap craft paints in light blue, lavender, white and gray.

11 Create a circle at the center of the page by sponging on a dark gray paint using a makeup sponge. This will create a contact between the mandala and the background.

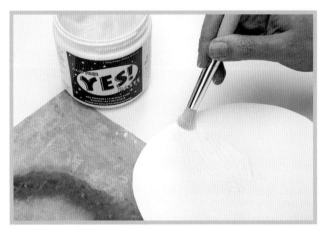

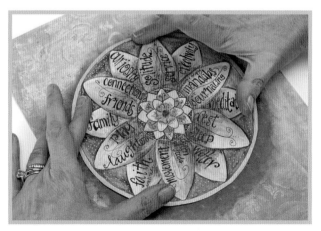

12 Once the background is dry, glue the mandala onto the background using Yes! paste applied with a stiff brush.

13 Firmly affix your mandala to the painted paper and enjoy! See page 116 for my completed *How I Blossom* mandala.

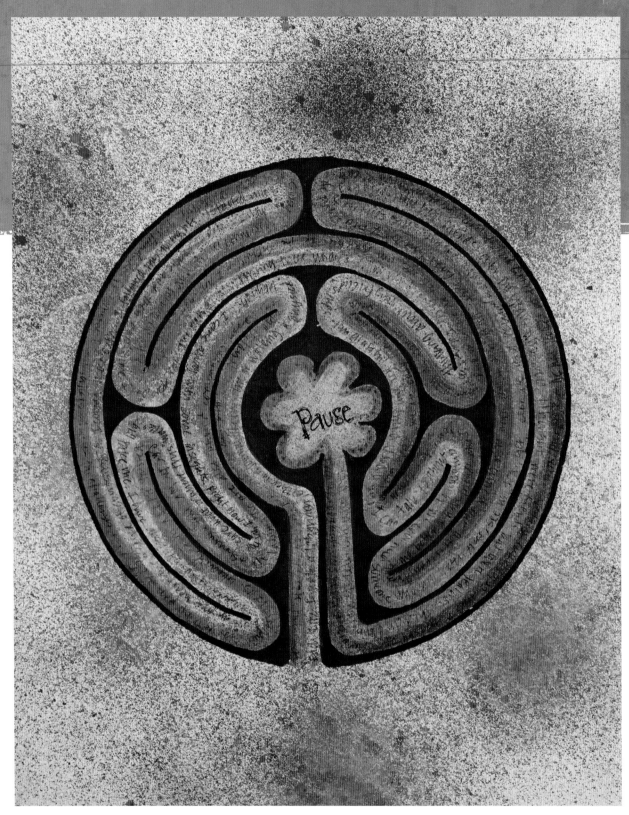

Time for Reflection

Think of each step in creating the labyrinth in your journal as part of your "walk." At first as you get to know this design form, your attention will be focused on the construction. Once you get into coloring the spaces in between and within the paths, your mind can wander. What is calling you to walk the labyrinth?

A Place to Pause | Kathryn Costa
Colored pencil, marker and ink sprays on bristol board

WALKING A LABYRINTH

BASED ON A SPIRAL, A LABYRINTH IS A CIRCUITOUS PATH that leads to a center point. Unlike a maze that has many branching paths, a labyrinth has a single path that is easy to follow. You can't get lost!

Dating back over 3,500 years, labyrinths have been found in Crete, Egypt, Italy, Scandinavia and North America. There are several labyrinth designs, some found within circles and others in squares. The classic design has seven rings (or circuits). In the Middle Ages, the Catholic church adapted the labyrinth for its own purposes within its cathedrals. The most famous is the Cathedral of Chartres, France, that has a more intricate design of eleven circuits in four quadrants, referred to as the "medieval design." A replica of the Chartres Cathedral labyrinth can be found at Grace Cathedral, an Episcopal church in San Francisco. Labyrinths, often lined with stone, shrubs or gravel, can be found in public places and private homes.

There are many ways to walk a labyrinth. Some begin by setting an intention or asking a question; others use this time for prayer, and for others it is a form of meditation. There is no right or wrong way to walk a labyrinth.

To walk a labyrinth in our journal, we will begin by drawing a labyrinth based on the center five circuits of the medieval design in Chartres, France. The path is wide to provide plenty of space to journal as you travel to and from the center.

MATERIALS LIST

- paper of your choice
- pencil and eraser
- compass
- ruler
- colored pencils
- black fine point pen
- ink sprays
- charcoal pencil
- ballpoint pen

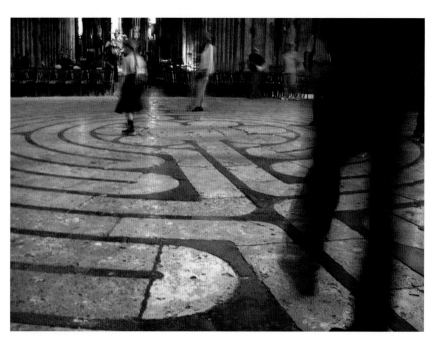

A Longheld Tradition
Walking a labyrinth at the cathedral of Chartres, France. To learn more about labyrinths visit these websites: labyrinthsociety.org and veriditas.org.

2 Draw a line from the bottom to the middle circle at the center. Draw two more lines, one on the right and one on the left, each ½" (13mm) distance to the first center line.

1 Make six concentric circles using a pencil and compass. Start by drawing a 2" (5cm) circle in the center and five more circles each ½" (13mm) larger than the previous circle.

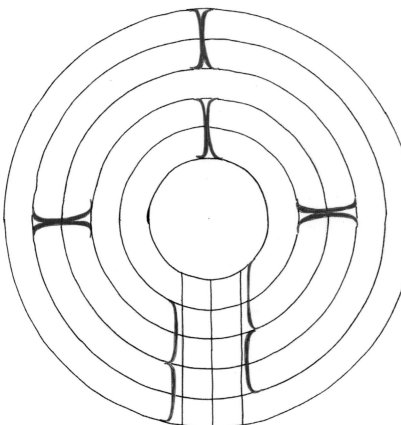

3 Mark the labyrinth turns using a long X. Start at the top marking an X through the first two pathways.

Skip a path and draw an X through the next two paths.

On the left draw an X through the second and third paths.

On the right draw an X through the third and fourth paths.

At the bottom on the left of the center pathways, mark a turn through the first and second paths and the third and fourth paths.

At the bottom on the right, mark a turn through the second and third paths and the fourth and fifth paths.

4 Trace the path with a pen, leaving a space at each turn and spaces at the top and left-side entrances, and at the bottom and right-side entrances. Erase the pencil lines.

5 Begin your labyrinth walk as you color and embellish the path. This is a good time to consider your intention or to ask a question. Here I used yellow, orange and pink colored pencils. Color over the path several times to get a nice vibrant color. Follow your thoughts as you create.

6 Once you have your labyrinth colored, you can stop there or continue your labyrinth walk by journal writing along the path with a ball-point pen. Start at the opening at the bottom and work your way around until you get to the center. Allow your thoughts to spill out onto the page.

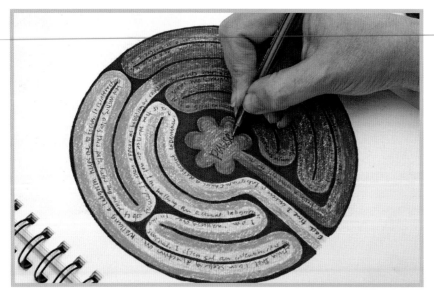

7 When you get to the center, pause for how-ever long it feels right for you. This is a time to listen to your inner wisdom. When you are ready, continue to write along the path following the twists and turns until you get to the exit.

8 You may stop here or continue to distress the labyrinth. I used an eraser to make some of the words illegible.

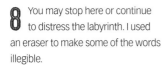
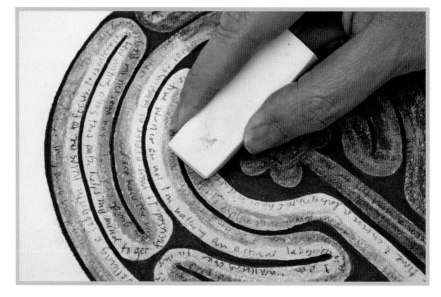

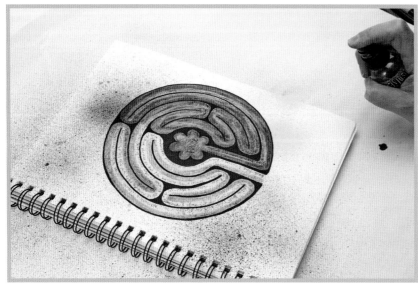

9 For additional color and texture, spray on some yellow and orange ink sprays. See my finished mandala on page 120.

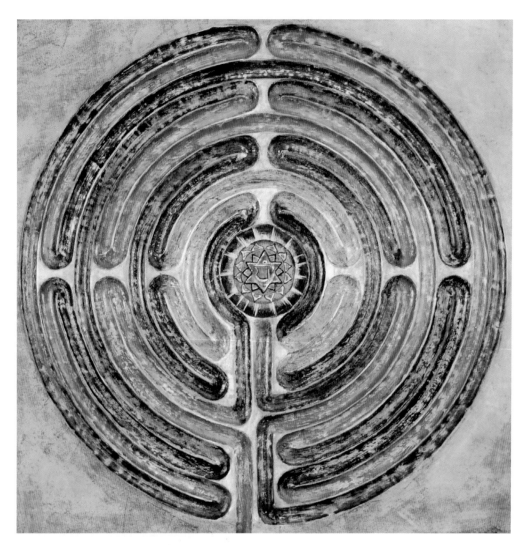

**Heart Chakra
Finger Labyrinth**
Fernando Costa
Acrylic on hand-
carved wood
mandala

Finger Labyrinths

Small handheld labyrinths are made of different materials and intended for "walking" by tracing your finger along the path. Follow these suggestions while tracing over the labyrinth that you created in your journal:

1. Trace the path using your nondominant hand.
2. Stay open to whatever presents itself: feelings, thoughts, memories, images, knowings.
3. Follow your breath.
4. Repeat a mantra, sound or word that is meaningful and sacred to you.
5. Walk with a question and be open for an answer.
6. Recite intercessory prayers.
7. If strong emotions arise, set your intention for healing and release.
8. If you are struggling with a problem, ask for guidance or insight: What message do I need to hear right now?
9. If you are not feeling balanced, you may ask a question: What needs my attention right now?
10. Take a gratitude walk. As you travel the path, count your blessings.

Personal Symbols

Whenever I am at a crossroads in life, I look to this compass on the cover of my journal. I spend time reflecting on the questions that relate to each symbol. Sometimes I'll record my thoughts in a journal or I'll "walk" a finger labyrinth (see previous page).

True North Compass | Kathryn Costa
Mixed media and collage on hardbound journal

True North Compass

MATERIALS LIST
..

drawing paper

compass

protractor

ruler

pencil

scissors

painted papers with wood icing

paint pens

glue

foil paper scrap

game spinner with brad

decorative paper or wallpaper scrap

hole punch

stiff brush

black marker or ink

EVERYONE HAS A "TRUE NORTH." It is the direction that points to your unique life's path and what you are called to be. Each one of us has been born with a unique set of gifts and talents.

I was forty years old when I first discovered that I had a True North. For most of my life, I had made safe choices often influenced by the desire to win my dad's approval. When I became a mother, my choices then were about making a good home and providing for my son. It wasn't until I turned forty when I felt a longing for something different. I wanted a life that was not just about working to pay bills and taking care of others, but I yearned for a life that expressed my deepest desires: to create and connect. Not sure what I wanted or where my path would take me, I followed a process that involved writing in my journal and creating art to express my thoughts and feelings. Drawing and reflecting on mandalas was one way that helped me to gain clarity and confidence. While I may not always know what is next in my life, what I do know is that I feel happiest when I'm following my True North.

This True North Compass project is designed to give you a tool for tuning in to listen and reflect on your heart's desire. Each direction has a place for a personal symbol. Questions for each symbol invite you to consider where you are at, where you have been and what's next.

Are you ready to connect to your True North?

1 Plan your layout. When piecing together a collage with a lot of pieces, begin by planning the layout. For this mandala layout use your compass to draw a 6" (15cm) circle and divide it into eight segments using your protractor and ruler (see chapter 2 on how to draw a grid mandala). Draw one 3¼" (8cm) circle, and one 2¾" (7cm) circle from the center. Use your compass or a circle stencil to draw eight 1¼" (3cm) circles on each of the segment lines.

2 (See following two pages.) Find your direction! Design a symbol for each direction of your compass in 1¼" (3cm) circles. Each of the symbols were created using painted papers and embellished with paint pens and black markers. Reflect on the questions in your journal to explore where you are at, what you need, and where you are heading.

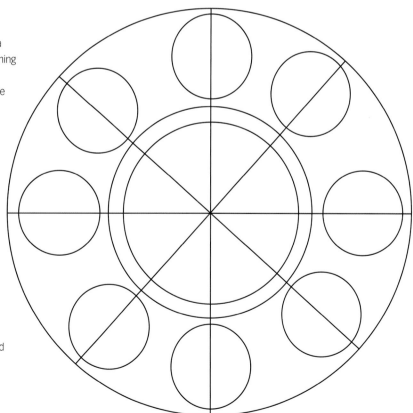

North

What guides you and keeps you on track? What prevents you from getting lost? I chose a heart symbol as I look to my heart and focus on love as my guiding principle. You may choose to use a symbol of your faith or another symbol that has personal meaning for you.

Northeast

As you think about your current path and goals in life, are you on target? I used contrasting colors to design a target.

East

What is on the horizon for you? What new areas are dawning in your life and in your future? The background paper was altered using star-shaped sequin waste. The many stars represent the many possibilities on the horizon.

Southeast

Who are your companions on your journey? Do you have a totem animal that guides you? The owl is one of my animal guides. You may create a symbol that represents an animal or an important person in your life who helps you on your journey.

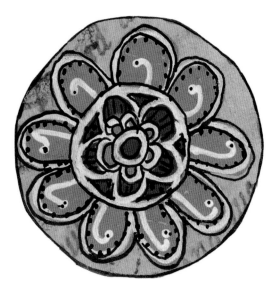

South

What helps you to blossom and to be your best? What gives you energy? Where do you go and what do you do to get away from it all in order to recharge yourself? Refer to the flower blossom project in chapter 10 to explore this topic further.

Southwest

Consider where you've been and your roots. What has prepared you for your current path?

West

What is coming to an end in your life? What areas of your life do you feel the sun is setting on? What are you ready to let go of?

Northwest

Each of us has the power to transform ourselves and make great changes. We experience change many times throughout our lives. What changes are you ready to make in your life to move forward on the path of your dreams? I cut out a photo I had taken of a butterfly to represent the changes that need to fly in the direction of my dreams.

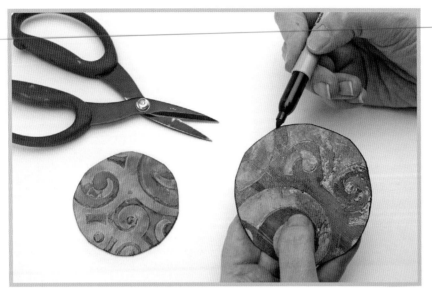

3 Select two pieces of decorative paper in contrasting colors. These may be painted papers or wood icing painted papers as shown here (see chapter 9). Cut them into two circles, one 3¼" (8cm) and one 2¾" (7cm). Ink the edges of the circle with a black permanent marker or stain them with dark ink.

4 Add a layer of detail with a foil paper scrap. Here, my embossed foil paper trim is also known as Victorian scrap, German scrap or a Dresden. They are made in Germany on machines 60 to 200 years old. They are sold in sheets and come in a variety of colors. They can be painted and distressed using sandpaper.

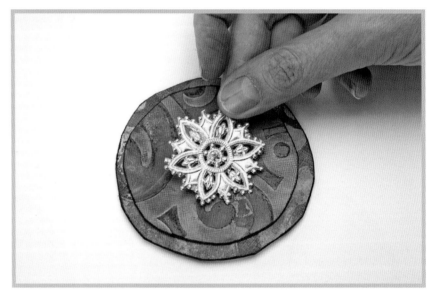

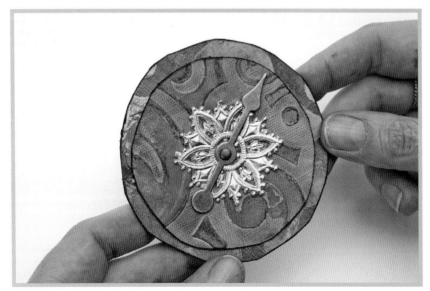

5 Punch a hole in the center of the compass base. Attach the papers from step 3 and the foil paper scrap from step 4 with a Tim Holtz idea-ology game spinner and brad.

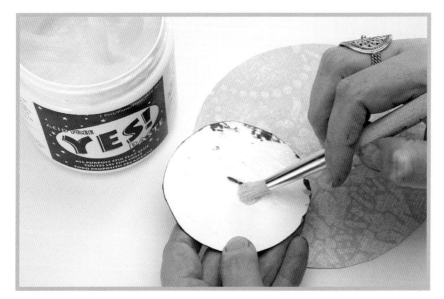

6 Choose a decorative paper to use as the background for the compass pieces. I chose a wallpaper sample in a neutral color with a pretty pattern. Cut the paper in a 6" (15cm) circle and glue the compass's center element. I like to use Yes! paste, a sturdy glue that adheres well for heavy and bulky design elements.

7 Attach all of the pieces to the background circle with more Yes! paste. Brush it on using a stiff brush. Excess paste will wash clean with soap and water. I chose to attach the final compass to the cover of one of my journals glued with Yes! paste. See page 126 for my final design.

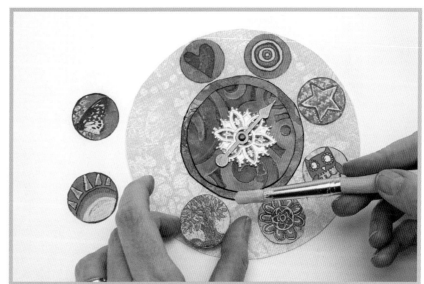

"One of the most calming and powerful actions you can do to intervene in a stormy world is to stand up and show your soul." —Clarissa Pinkola Estés

MICHAEL O'NEILL MCGRATH

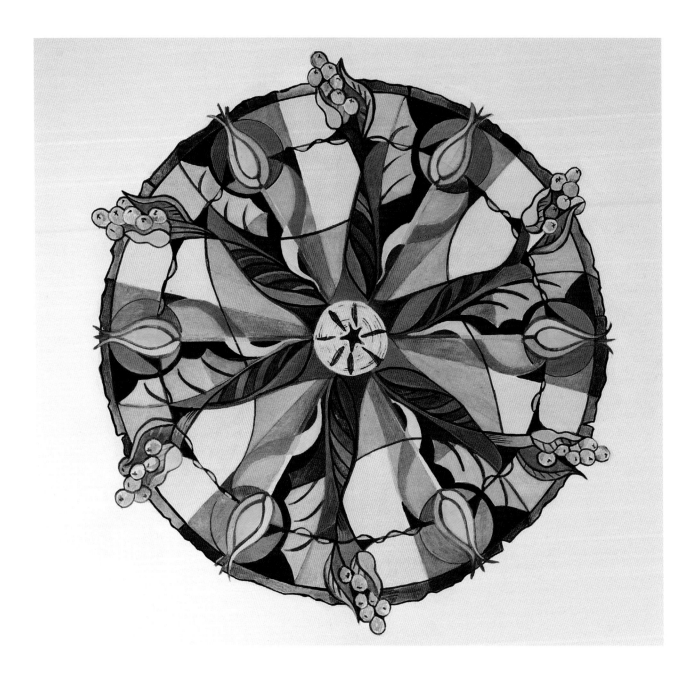

BROMICKEYMCGRATH.COM

Painting *Tree of Life* was a true game changer in my life's work. It was the first mandala that I created with deep, prayerful focus. It came to me in days of profound grief following the death of my best friend. I found myself open to a new experience of letting go of old approaches and expectations.

Tree of Life
Michael O'Neill McGrath
Acrylic on board
Camden, New Jersey, USA

DONNA GENTILE

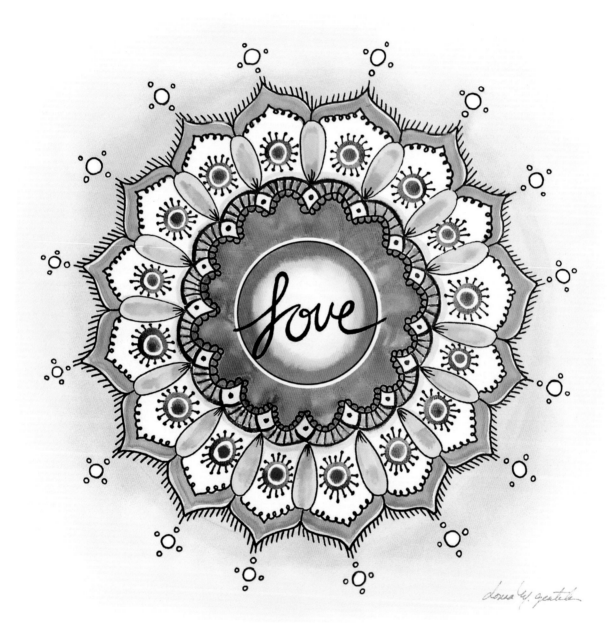

DONNAGENTILE.COM

Making mandalas helps me tell my story anew, express gratitude, attract positive people, energy and things, and make the transformations I desire in life. It allows me to celebrate my authentic self, focus, relax, set goals, connect and work through difficult thoughts and emotions. Mandalas are a powerful creative tool for personal growth and healing.

Love Mandala
Donna Gentile
Watercolor and ink on canvas
Pine Meadow, Connecticut, USA

irina Artamonova

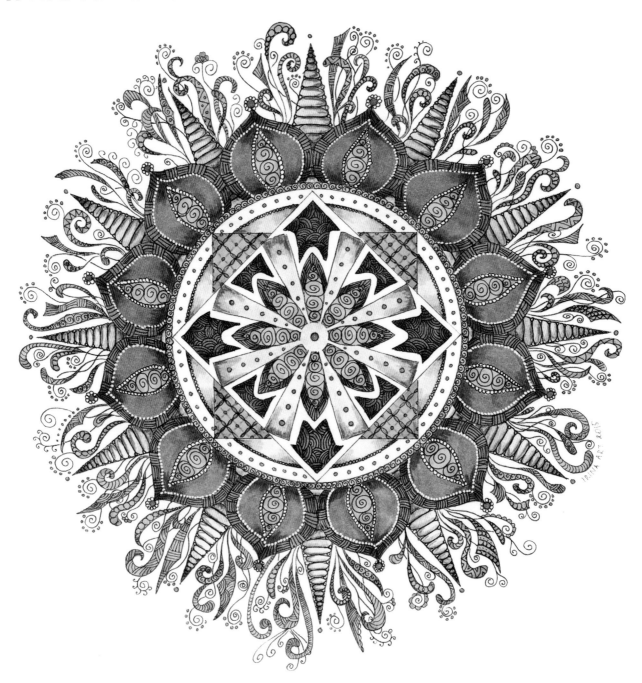

I started drawing mandalas at a time in my life when I was emotionally and physically burned out. After taking a course on sacred geometry, I drew mandalas almost every day for a couple of months. My mandala practice has taught me to relax and let go of my internal critic.

Fairytale Mandala
Irina Artamonova
Artist's pens, gel and felt-tip pens,
and markers on paper
Moscow, Russia

Jackie Fuller

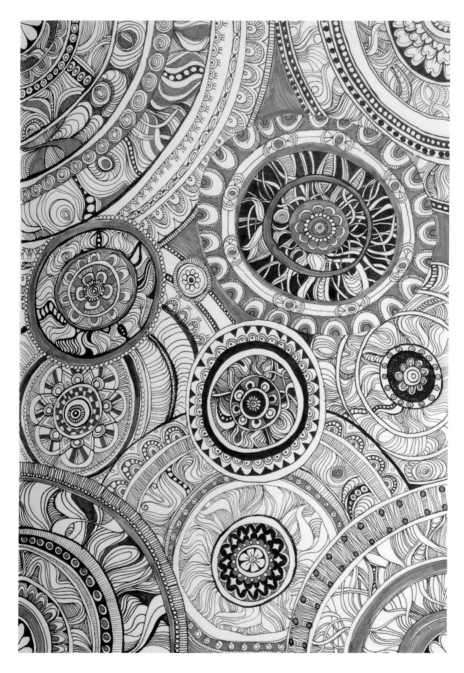

SPAREROOMSTUDIO.DEVIANTART.COM
Creating mandalas in my journal is a way to empty my mental chatter onto paper. Often I fill the paper with parts of mandalas rather than the whole, none of it planned or measured. I'm learning to let go of expectations of perfection and value the process rather than the result.

Multi Mandala Journal Page
Jackie Fuller
Ink and markers on journal page
South Australia

jane LaFazio

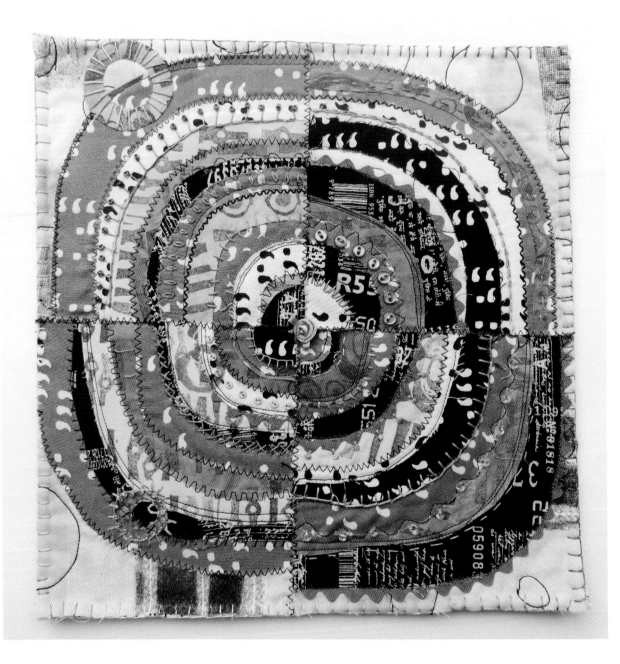

JANELAFAZIO.COM

It is nearly impossible to create a perfect mandala or circle using my method to create my *Recycled Circles* artwork. The wonkiness of the shape, the variety of fabrics and the unmatched seams all add to the charm of the piece! I like the whole random quality.

Recycled Circle
Jane LaFazio
Thread, beads, buttons and cotton fabric
San Diego, California, USA

LOUISE GALE

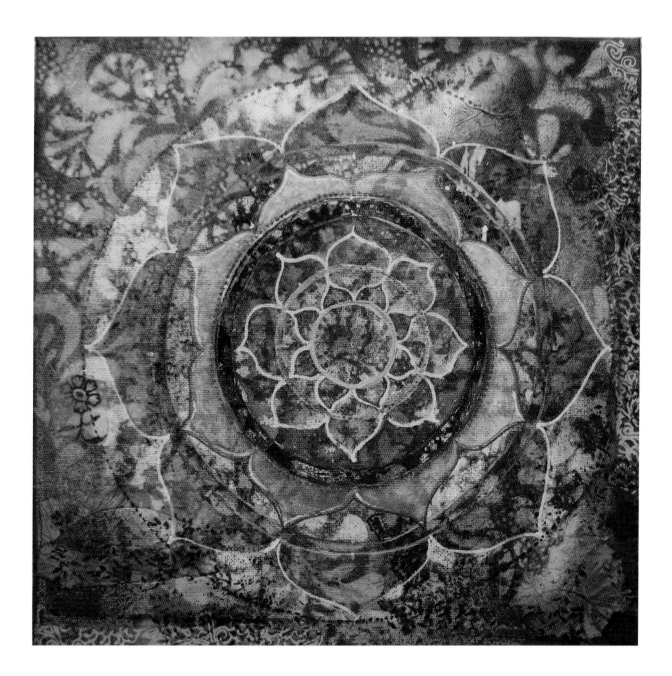

LOUISEGALE.COM

Creating a mandala has become a form of meditation for me, which enables me to calm my mind, slow my breathing and sink more deeply into the creative zone. I love the calm contemplation of growing a mandala from the center to see a beautiful design emerge.

Sunset Meditation Mandala
Louise Gale
Acrylic, watercolor, spray paint and pressed hibiscus flowers on canvas
Malaga, Spain

maria mercedes trujillo a.

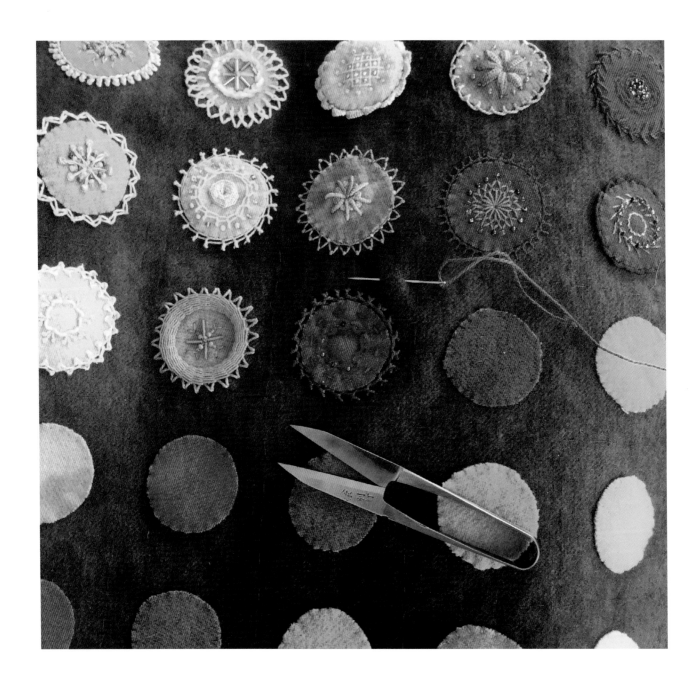

MAGAMERLINA.COM

When I moved to New Zealand from Bogotá, Colombia, I had a very difficult time deciding what I wanted to do. I wasn't sure I wanted to be a doctor anymore. Drawing mandalas in my journal, I found the passion for life, the looking forward to a new project, and I had found my purpose.

Little Universes

Maria Mercedes Trujillo A.
Various embellishment threads and glass beads on hand-dyed wool-felted fabric
New Zealand

Neomi Mor

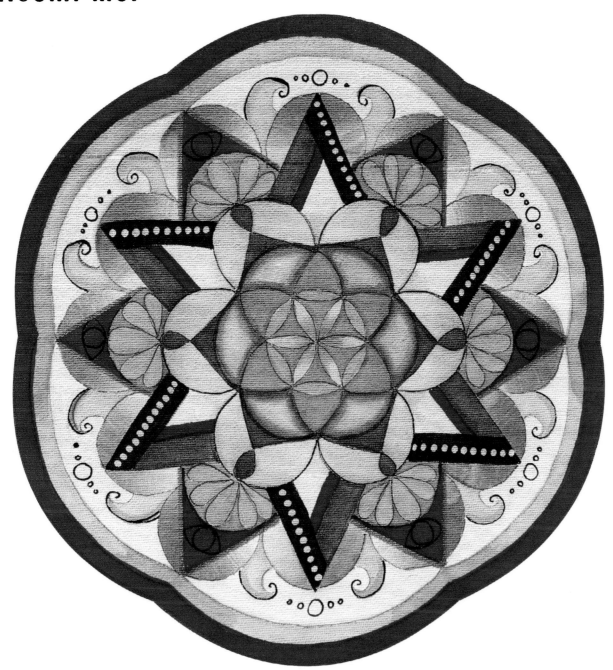

Drawing mandalas has opened a new channel of creativity to express myself. I love the creation of a new symmetric and enchanting symbol out of a simple piece of white paper. Drawing mandalas is a kind of meditation for me. It gives me joy and calmness and heals me during tough periods in life.

A Flower in the Desert
Neomi Mor
Alcohol-based markers and ink
pens on canvas
Israel

patricia mosca

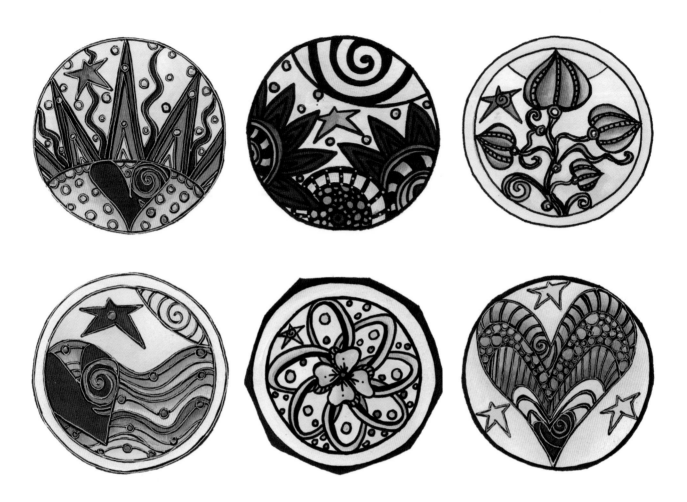

**SOULFULLYJOURNALING.
BLOGSPOT.COM**

Usually before I start my day, I work in my mandala journal.
I light a candle and sit quietly and ask one simple question:
"What is it that I need to be aware of today?" Sometimes
a word comes to me; other times it is a picture or a series
of words.

Mandalas from Patricia's Journal
Patricia Mosca
Acrylic paints and markers on
journal pages
Rochester, New York, USA

Tara Asuchak

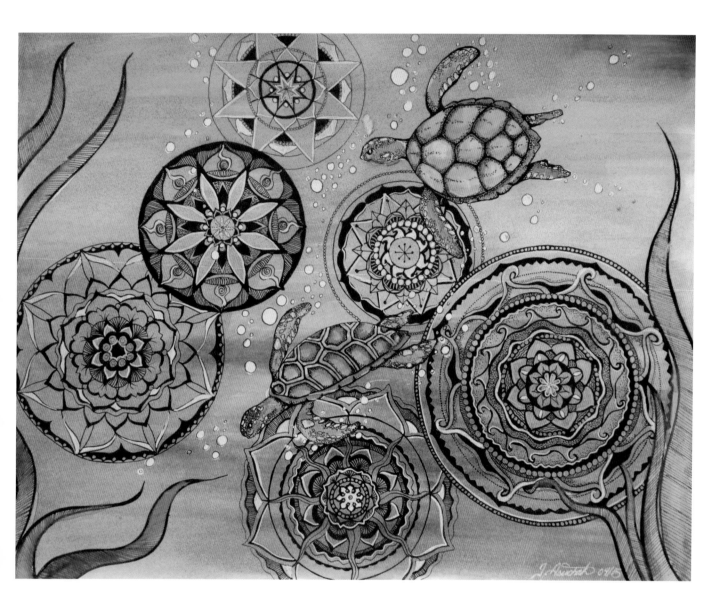

INSTAGRAM.COM/TARALMAC

Sometimes I draw mandalas with no expected outcome. I do it to clear my mind and to relax. Other times I have a specific intention like this mandala of the turtles. I was thinking of my grandmother who passed eleven years ago and who loved turtles and always wanted to go to the Great Barrier Reef.

Swimming with the Turtles
Tara Asuchak
Black ink pens, markers, watercolor and white ink on mixed-media paper
Alberta, Canada
Photo credit: Tim Ranson

index

The Mandala Guidebook. Copyright © 2016 by Kathryn Costa.
Manufactured in China. All rights reserved. No part of this book may
be reproduced in any form or by any electronic or mechanical means
including information storage and retrieval systems without permission
in writing from the publisher, except by a reviewer who may quote brief
passages in a review. Published by North Light Books, an imprint of
F+W Media, Inc., 10151 Carver Road, Suite 200, Blue Ash, Ohio 45242.
(800) 289-0963. First Edition.

a content + ecommerce company

Other fine North Light Books are available from your favorite
bookstore, art supply store or online supplier. Visit our website at
fwcommunity.com.

20 19 18 5 4 3 2

Distributed in the U.K. and Europe
by F&W Media International, LTD
Brunel House, Forde Close, Newton Abbot, TQ12 4PU, UK
Tel: (+44) 1626 323200, Fax: (+44) 1626 323319
Email: enquiries@fwmedia.com

ISBN 13: 978-1-4403-4420-6

Edited by Sarah Laichas
Designed by Clare Finney
Photography by Christine Polomsky
Production coordinated by Jennifer Bass

ABOUT THE AUTHOR

Kathryn Costa is an artist, writer
and educator whose passion can
be summed up in three little words,
"create and connect." Since she
started blogging in 2008, Kathryn has
inspired people from more than 90
countries with her personal stories
and artwork. Kathryn's workshops
seek to help people find clarity, let go
of fear, embrace their dreams and explore their creativity.

While teaching a high school graphic design program more
than 17 years ago, Kathryn discovered mandalas from a colleague
who had studied art therapy. Her first mandala project was facilitat-
ing a group mandala with her graphic design students. Since then,
the mandala has been a recurring theme and motif in her work. In
October 2014, Kathryn decided to challenge herself to create 100
mandalas in 100 days and invited her friends online to join her. Within
a year, the 100 Mandalas Challenge and Community has quickly
grown to include thousands of mandala enthusiasts from all over the
world. Visit 100mandalas.com.

When Kathryn isn't creating mandalas, she enjoys art journaling,
collage, mixed media, photography and ikebana (Japanese flower
arranging). She lives in New England with her Brazilian husband,
Fernando.

DEDICATION

To all of my mandala family who have made the 100 Mandalas
Community a place of beauty, love and support. For my son, Loki:
May you see this book and know that your dreams are always within
reach. For my husband, Fernando, who has been on this mandala
journey at every turn. I love you!

ACKNOWLEDGMENTS

Thank you, Kelli Cody, for introducing me to mandalas 17 years ago.
All of the contributors who grace these pages with their inspiring
mandala art. Tonia Jenny for loving my book idea. My editor, Sarah
Laichas, for your guidance. Clare Finney (cover and interior design)
and Christine Polomsky (photographer) for making me look great!
Susanne Fincher, Marilyn Clarke and Susan Johnson for sharing your
wisdom and love for mandalas. Celia, Beth, Tom, Sarah Jane, Mary
Ellen, Mary Jane and Gertrude from my work circle who all patiently
listen to me talk about mandalas whenever I get a chance. Claudia,
Karen, Terri, Salina, Antonio, Bobbi, Chris, Pam, Nancy, Wendie and all
of my dear friends—too many to name here. Thank you for believing
in me and being a part of my inner circle. Lastly, to my parents, who I
know have been guiding my every step.

IDEAS. INSTRUCTION. INSPIRATION.

Receive FREE downloadable bonus materials when you sign
up for our free newsletter at ClothPaperScissors.com.

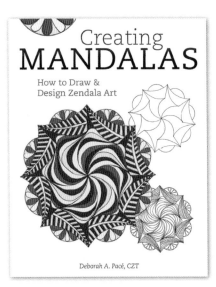

Find the latest issues of *Cloth Paper Scissors*
on newsstands, or visit artistsnetwork.com.

These and other fine North Light products are
available at your favorite art & craft retailer,
bookstore or online supplier. Visit our websites at
artistsnetwork.com and artistsnetwork.tv.

Follow ClothPaperScissors for the latest
news, free wallpapers, free demos and
chances to win FREE BOOKS!

GET YOUR ART IN PRINT!

Visit artistsnetwork.com/competitions
for up-to-date information on *Incite* and
other North Light competitions.